DONCASTER'S COLLIERIES

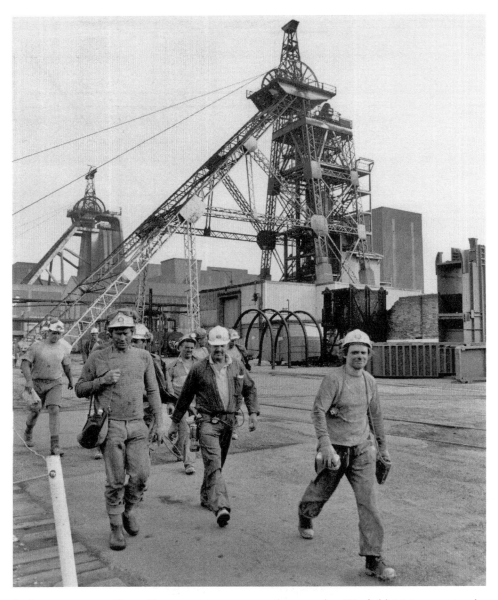

In January 1952 a *Don. Chron.* reporter went underground at Hatfield Main to write the following: 'Stepping out into the strange new world I marvelled at the high dusty cavern, illuminated by fluorescent lighting. The unreality of the scene was completed by the arrival of a diesel-powered "paddy" train running on rails, of which there are 40 miles below. The heat becomes almost overpowering. The coal dust combines with unusual odours, like burning diesel, and I cannot ignore the sensation of nausea. Miners begin to pass and I find it hard to detect any human features through the grime on their faces. We are getting near the coalface now for I notice a steady stream of coal passing along a conveyor. The mechanical cutter had been here yesterday, leaving its trail of broken coal, yet the men still have to work hard to "win" it on to the conveyor. One man stoops to almost half his height as he drives a drill into the face to prepare holes for shot firing. Working hard only a few feet away from the driller, is 43-year-old Hector Laidler of Broadway, Dunscroft. He is dressed only in shorts, socks and boots and every part of his body is coated with dust. He said "Those who say we have an easy job should come and have a seven-and-half-hour bash at this seam for a few days. They would get a headache that would last for weeks".' Miners are seen here after finishing a shift at Hatfield Colliery.

DONCASTER'S COLLIERIES

PETER TUFFREY

AMBERLEY

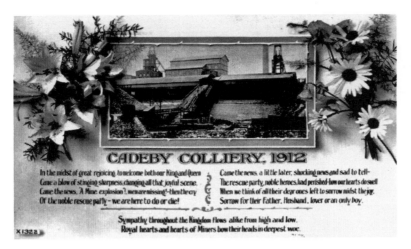

Cadeby Colliery disaster postcard, the words reading: 'In the midst of great rejoicing to welcome both our King and Queen. Came a blow of stinging sharpness changing all that joyful scene. Came the news. A mine explosion! Men are missing – then the cry of the noble rescue party – we are here to do or die! Came the news a little later, shocking news and sad to tell. The rescue party, noble heroes, had perished – how our hearts do swell. When we think of all their dear ones left to sorrow amidst the joy. Sorrow for their Father, Husband, lover or an only boy. Sympathy throughout the Kingdom flows alike from high and low. Royal hearts of miners bow their heads in deep woe.'

Acknowledgements

I would like to thank the following people for their help: David Clay, Dave Douglass, John Law, Paul License, Hugh Parkin, Jane Salt, Andrew Shaw, Sheila Shaw, Tony Wormley.

Special thanks to my son Tristram Tuffrey for his help behind the scenes.

First published 2011

Amberley Publishing
The Hill, Stroud
Gloucestershire, GL5 4EP

www.amberleybooks.com

Copyright © Peter Tuffrey, 2011

The right of Peter Tuffrey to be identified as the Author of this work has been asserted in accordance with the Copyrights, Designs and Patents Act 1988.

All rights reserved. No part of this book may be reprinted or reproduced or utilised in any form or by any electronic, mechanical or other means, now known or hereafter invented, including photocopying and recording, or in any information storage or retrieval system, without the permission in writing from the Publishers.

British Library Cataloguing in Publication Data.
A catalogue record for this book is available from the British Library.

ISBN 978-1-4456-0126-7

Typesetting and Origination by Amberley Publishing.
Printed in Great Britain.

Contents

Introduction	7
Armthorpe (Markham Main) Colliery	9
Askern Colliery	19
Barnburgh Colliery	29
Bentley Colliery	37
Brodsworth Colliery	47
Bullcroft Colliery (Carcroft)	55
Cadeby Colliery	67
Denaby Main Colliery	79
Doncaster Coal Board Offices and Rescue Station	87
Edlington: Yorkshire Main Colliery	91
Hatfield Colliery	99
Hickleton Colliery	109
Rossington Colliery	115
Thorne Colliery	123

Miners at Edlington's Yorkshire Main Colliery hoist aloft retiring miner George Dungworth.

*This book is dedicated to the late
Frank Shaw and Lawrence 'Lol' Freeman,
who helped me greatly in the early stages of my career.*

Introduction

Born in Doncaster in 1953, I suppose I became aware of the town's industrial make-up in my teens, as most people become aware of the characteristics of their own area. I lived only half a mile away from Edlington's Yorkshire Main Colliery, and when visiting my maternal grandparents at Denaby, I passed Cadeby colliery where an uncle, George Nelson, worked as an electrician. Two of my great uncles, Jessie and Edmund Tuffrey, were also killed there in the 1912 explosion. Attending Swinton Comprehensive aged eleven in 1964, I passed Denaby Colliery, the awful back-to-back pit houses and the colossal cooling towers at Mexborough power station. So, it quickly became apparent as I travelled further round the Doncaster area that the town relied very heavily on the mining industry and the railways, working hand in glove, for its economic stability and growth. That's not forgetting all the other smaller feeder industries that supported them and found employment for a great number of people. If asked then if I believed that this industrial scenario could ever change, I would have yelled 'no' with as much conviction as possible.

Travelling regularly on the train to Leeds University between 1971 and 1974, I passed the vast South Kirkby Colliery complex and Lofthouse Colliery, where the terrible disaster occurred in 1973. So even when venturing beyond Doncaster, collieries were still to be found.

The 1972 and 1974 miners' strikes were perhaps a foretaste of what was to come, as the NUM flexed its muscles. OK, it was inconvenient during that period to endure the blackouts and the three-day working week but it didn't seem to matter. I couldn't draw or paint during the blackouts, but so what? Most people were behind the miners, especially in the Doncaster area, and desperately wanted them to win given the appalling conditions they worked in.

Matters progressed until Margaret Thatcher became PM in 1979. A woman as Prime Minister, what does she know? It seems embarrassing to ask that sexist question now, but it was often asked at the time, particularly in the Yorkshire coalfield. When Arthur Scargill was elected NUM president in 1981, everyone waited with eager anticipation for the heavyweight political contest that would take place between him and Margaret Thatcher.

Margaret Thatcher 'warmed up' in fights with several large trade unions, most notably the ISTC, and in her eyes emerged victorious. As a result she was full of confidence when the clash with the NUM occurred, but the opponents looked to be evenly matched and nobody could have guessed the outcome.

Living in Rossington at the time of the conflict, I was shocked to tune in to *News at Ten* one night in July 1984 to hear, after the first clang of Big Ben, 'Riots in Rossington: Trouble has flared on the picket lines in South Yorkshire.' Was I hearing correctly? This programme's headlines usually gave accounts of terrifying incidents abroad. This was on

my doorstep and not a mile away. Of course, as the weeks passed by and the movement of everyone around Doncaster and its surrounding areas became increasingly restricted, it dawned on everyone what was happening. Maggie's dirty tricks were afoot and gathering momentum to ensure she was not left with egg on her chin in this scuffle with the NUM, as Ted Heath had found himself previously.

So, brave in defeat, and with their heads held high, the miners trudged back to work in 1985, knowing what was to come during the remainder of the decade. Every Doncaster colliery (apart from Hatfield) has been closed, along with many in the surrounding areas. This has had a devastating effect in each mining area and still, in most cases, with vast reserves of coal left intact underground.

In the 1960s and 1970s, did I ever believe I would produce a book that could illustrate each of Doncaster's collieries from its inception to closure? Not in a million years. Yet the political climate was something no-one could have ever predicted.

I have taken the Doncaster Metropolitan Borough Council area to define the boundaries for this book, not the Doncaster area designated by the NCB/NUM.

To illustrate each chapter I have used images from my own collection and the collections of the late Frank Shaw and 'Lol' Freeman, as well as a few choice ones from the Sheffield Newspapers' picture archives. Information has been mainly gleaned from the *Doncaster Chronicle* or *Doncaster Gazette* or the offprints at Sheffield Newspapers. I am grateful to long-time NUM stalwart and author Dave Douglass for reading through the text and to Sheffield Newspapers' librarian Jane Salt for her time and patience. Tony Wormley also made useful comments.

Finally, I am usually happy and proud after compiling a book, and begin to write an introduction. But this one is different. Am I a little sad? Yes: after seeing each colliery community thriving and bound together in joy and suffering, it is very sad to see it all go, knowing many years will pass before regeneration occurs.

Armthorpe (Markham Main) Colliery

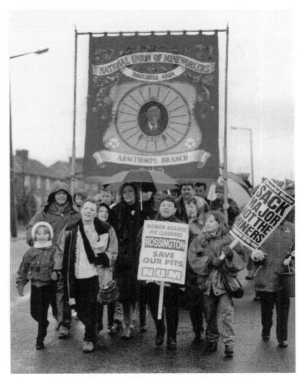

On 21 April 1993, Doncaster's defiant women pit campaigners celebrated a milestone in their bid to save thirty-one threatened collieries. The country's first pit-gate camp – established outside Markham Main Colliery, Armthorpe, was 100 days old. It was set up by Doncaster Women Against Pit Closures, who were highlighting the strength of feeling against the Tory government's alleged 'butchery' of the mining industry. Leading member Brenda Nixon, pictured with the umbrella in the above picture, marching through Armthorpe, said: 'This is a milestone for the camp. Markham Main was the first to be set up and it will remain here until the pit and the others like it are saved. It's been hard work, but well worth it. We have had literally thousands of visitors. People have come from all over the world to see us and sign our visitors' book, and we have been inundated with messages of support.'

The Greenham Common-style settlement was spawned during the previous year's occupation of Markham Main's offices by Brenda, Aggie Currie (front row, second from left) and women protestors from Barnsley and Sheffield. A number of the Greenham women turned up to help establish the Markham Main camp on 11 January, helping to start light a brazier which had burned continuously as a sign of determination since then. Within days, other camps began to spring up outside the ten most threatened pits in the land.

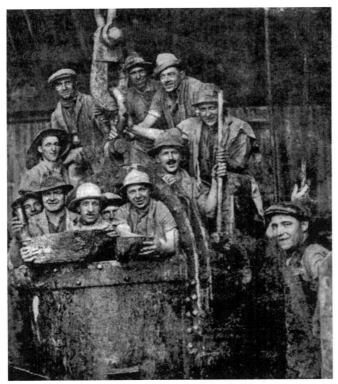

Left and below: The *Don. Gaz.* of 2 June 1922 reported that after many disappointments – including delays due to high wages, labour troubles and coal trade depression – sinking operations had resumed at Markham Main Colliery, Armthorpe. But it was still expected to take about three years to reach coal. It was not until the lease passed into the hands of Sir A. B. Markham, who had extensive colliery interests in the Doncaster district, that practical steps were contemplated. This was in 1913, and in that year a bore hole was sunk, with a second one in 1914, when good workable coal measures were proved. Sinking operations were postponed because of the First World War and were not actually started again until the early part of 1920, when there were more delays and disappointments. The picture to the left shows an early scene at Armthorpe, while the one below illustrates the powerhouse with a 1920 date stone.

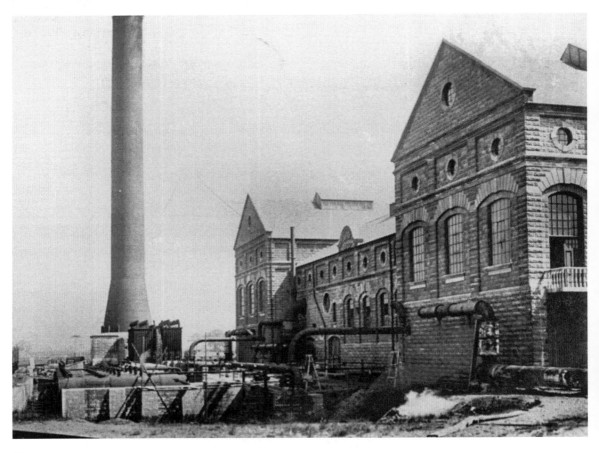

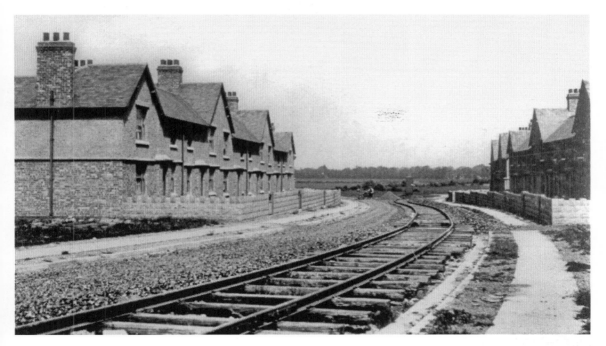

Above and below: In 1922, the *Don. Gaz.* (*op. cit.*) stated that the Armthorpe Colliery surface works were the last word in pithead construction. The headgear, of reinforced concrete, was an imposing structure and the towering steel chimney was a landmark for miles around. Abercrombie and Johnson (1922) said in the same year that the Armthorpe Colliery development, erected on some of the highest ground available, was designed on sound lines. It was sufficiently far away from the colliery to avoid the smoke from the pithead, and full advantage had been taken of the wooded surroundings of the new village site. The *Doncaster Chronicle* of 9 May 1924 explained that when the colliery got into its full stride, it would probably provide employment for 3,000 to 4,000 men. 'The model village when completed will comprise about 1,000 houses ... The village will be in the form of a semi-circle, and fine avenues of trees being comprised in it,' said the newspaper.

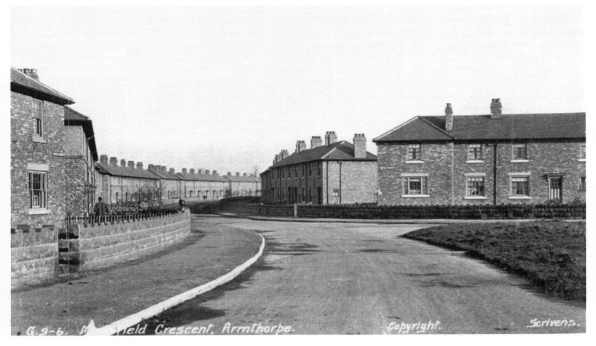

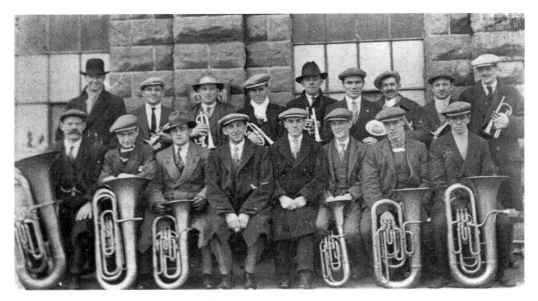

Above: Armthorpe's Markham Main Colliery St John's Ambulance band was formed in 1925. Colliery agent Tom Blunt, colliery manager Walter Criddle and Jock Wanliss were the three founder members. Pit deputy Joe Wilson was the first bandmaster and a set of second-hand instruments were acquired, band members paying weekly contributions to pay off their debt. Each player was also proficient in first-aid work. A new set of instruments was acquired in 1928, and the band entered its first contest in 1930. In 1945 the outfit was renamed Markham Main Colliery Band, and financial support was received when a weekly wage contribution of a halfpenny per man was granted from the NUM. Between 1945 and 1960 the band played at various venues including the annual Blackpool camps, Yorkshire Miners Demonstrations and also two ten-day tours of Holland, winning competitions there in 1952 and 1953. The band achieved national fame in the 1960s, winning the National Coal Board Yorkshire Divisional Championships in 1963, 1965 and 1966. The band became National Coal Board Champion Band in 1964 and 1965, and also competed in the National Finals of Great Britain at the Albert Hall during the 1960s. The Armthorpe lads' concerts at the Civic Theatre, Doncaster, in the 1970s were very popular and the band still continues to thrive.

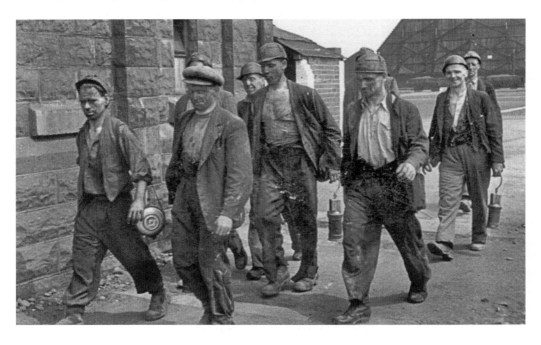

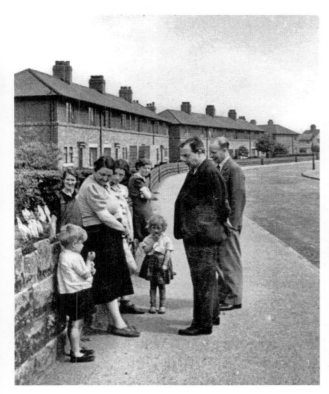

Above, left and right: In June 1941 the weekly pictorial magazine *Picture Post*, in conjunction with the Mines Department of the Board of Trade, made arrangements with John Hunter, MD of Doncaster Amalgamated Collieries Limited (DACL), for their official photographer Bert Hardy to visit Armthorpe Colliery. The visit, taking place on Friday 20 June 1941, formed the subject of an article entitled 'This Problem of Coal', which appeared in the magazine. The photographer was accompanied by writer J. B. Priestley, who was responsible for the write-up of the article. Hunter decided that they should visit Markham Main, where the celebrated Barnsley seam was worked in a manner typical of the Doncaster Coalfield. Prior to his visit to the underground workings, Priestley was conducted through Armthorpe village adjacent to the colliery, where the houses, numbering almost a thousand, were the property of the DACL. All the pictures illustrated in the article were captioned and one beneath the picture on the left read: 'This mother was not sure if her son was to become a miner. "It will be alright if he can go to a modern mine such as Armthorpe," she said, whilst Mr Priestley and Mr Haslam looked on.' The caption for the picture on the right: '"Gerry" Margerison, at his front gate, discusses the economics of his work with Mr Priestley.'

Opposite below: Underground workers en route to the lamp cabin at the end of the shift.

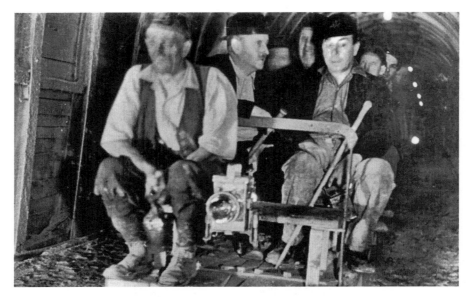

Priestley, right, underground at Armthorpe. In the *Picture Post*, Priestley wrote: 'The connection between coal and our war effort hardly needs stressing. A shortage of fuel for the war factories, or for the power plants that feed those factories, and we shall have dwindling supplies of munitions. If there should be a famine in house coal, then there will be more illness, more discomfort, and a drop in morale. Thus the coal problem is an essential problem, and we cannot afford to trifle with it.' About miners themselves, Priestley wrote: 'The average miner is a good steady citizen, and indeed has to be to pursue properly his own and dangerous trade ... He is usually a responsive, generous, fairly emotional chap (who likes to let himself go at a meeting) ... And he likes to feel that the general community is appreciating his essential effort, that grimy and sweaty hacking and tugging far underground.'

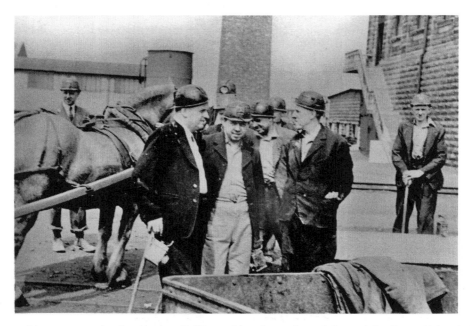

Among this group at the Armthorpe Colliery pithead are, from left to right, Pony 'Prince'; J. S. Raynor, chief electrician; J. Hunter; J. B. Priestley; T. Baynham of the Bullcroft Branch of the Yorkshire Mineworkers' Association; H. J. Humphrys; and B. Schofield, delegate of the Armthorpe Branch of the Yorkshire Mineworkers' Association.

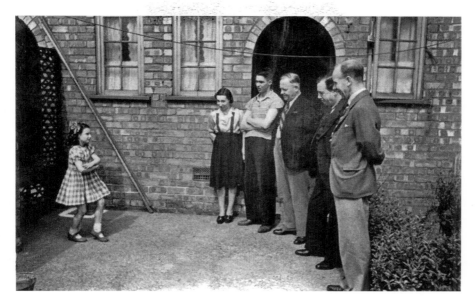

The *Picture Post* reported that 'Mr and Mrs Ralph Bell were sure that their small daughter would interest J. B. Priestley – here joined by Mr J. Hall, President of the Yorkshire Mineworkers' Association. Betty has made good progress in her tap dancing lessons.'

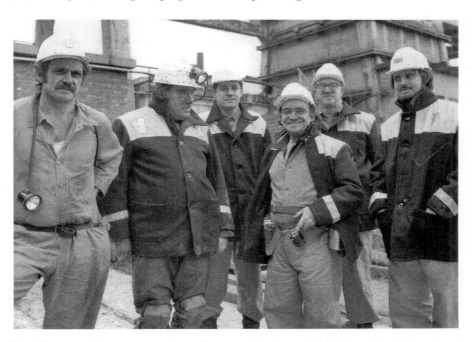

Harold Walker (12 July 1927 – 11 November 2003) is pictured third from the right at Armthorpe Colliery. Born in Audenshaw, Harold was elected Labour member of Parliament for Doncaster at the 1964 general election. He was a junior whip and then junior employment minister in the first Harold Wilson government, and continued being spokesman on employment in opposition, returning to the ministry in 1974. He was Minister of State at the Department of Employment 1976–79 and became a Privy Counsellor in 1979. Harold left the employment brief in 1983 following that year's general election and became Chairman of Ways and Means, making him Deputy Speaker to Bernard Weatherill. He was knighted in 1992 and returned to the backbenches. Walker retired in 1997 and was made a life peer as Baron Walker of Doncaster, of Audenshaw in the County of Greater Manchester.

Above and below: Pickets and police outside Armthorpe Colliery during the 1984/85 Miners' Strike, 21 August 1984. Under the heading 'Strike Breaking', *Wikipedia* states: 'The refusal of some miners to support the [1984–1985] strike was seen as a betrayal by those who did strike. The opposite positions of miners in the adjacent coalfields of Yorkshire and Nottinghamshire, where the former were striking and the latter strike-breaking, led to many bitter confrontations in the region.' In Armthorpe a number of the so-called 'strike breakers' or 'scabs' or 'black legs' came under attack. One individual's house was daubed with white gloss paint and a blue aerosol paint spray was used to smear his front door. The paint also hit neighbours on both sides. In another incident, a miner's fourteen-month-old car was covered in red paint. The attack on the car came just as NCB workmen finished repainting his house after it was daubed in brown and white paint.

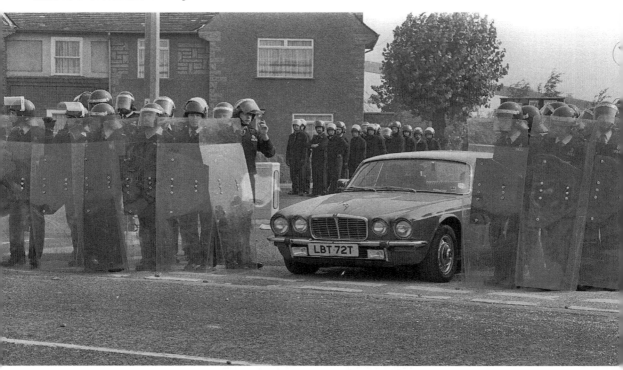

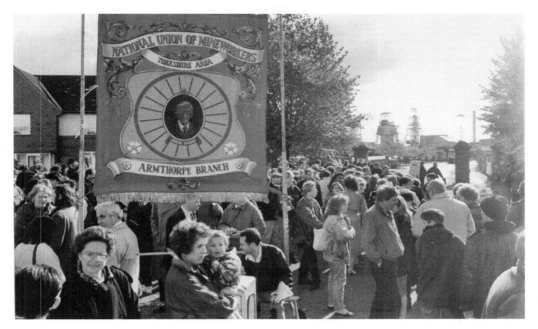

Above and below: Rally through Armthorpe and scene outside the colliery gates on 15 October 1992. In May 1993 it was announced that the women's camp at Markham Main Colliery, a symbol of defiance against the closures for over 130 days was to shut. Women Against Pit Closures vice-president Brenda Nixon said: 'We feel that we have done all we can at Markham Main, although we are still going to carry on fighting against the closures.' Thousands of well-wishers had visited the camp since it was set up and was featured regularly on news broadcasts in Britain and abroad as the women's fight to save pits grabbed media imagination. Support also came from Doncaster Council leader Gordon Gallimore, who authorised the loan of a portable building and bottled gas supplies.

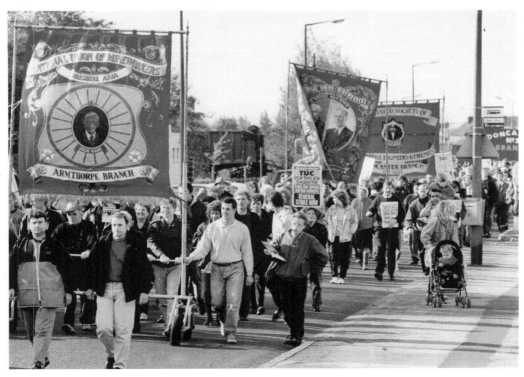

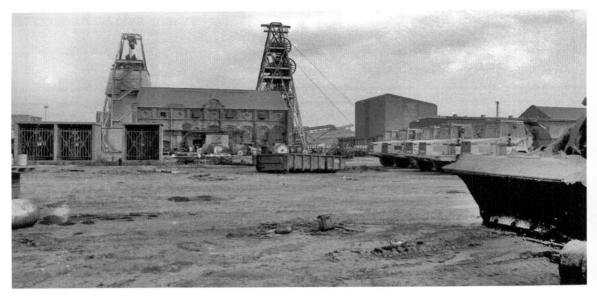

View at the colliery shortly after closure. The 'covered' headgear on the left is the upcast shaft.

The *Don. Star* of 19 November 1993 stated Armthorpe Colliery, seen above, had shut in 1993 and was available for lease/licence. A brave attempt was made by Michael Edwards, a former NCB director who bought the colliery and made an effort to bring it back to production and profitability. But in the end this came to nothing. In subsequent years the area was cleared.

Askern Colliery

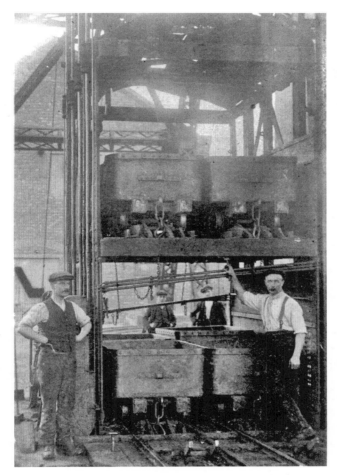

The *Don. Chron.* of 27 January 1911 reported: 'Within a comparatively short space of time, almost incredible at the moment though it seems, Askern Spa will cease to be the resort of the fashionable and the wealthy, the seeker after rest, repose, peace and quietude and the beauties of nature, and will have itself become the scene and centre of a commercial community, having in its very heart a great, throbbing, pulsating pit, belching forth smoke from its chimneys, and raising at the rate of 4,000 tons per day, when fully developed, those black diamonds which are now so greatly sought after in South Yorkshire.' The Askern Coal & Iron Company was formed in March 1910 to work for coal under the Campsall and Campsmount estates and adjoining lands. The company was a combination of the Bestwood Coal and Iron Co., Nottingham, and the Blaina Colliery Co., Monmouthshire, with a registered office in Doncaster.

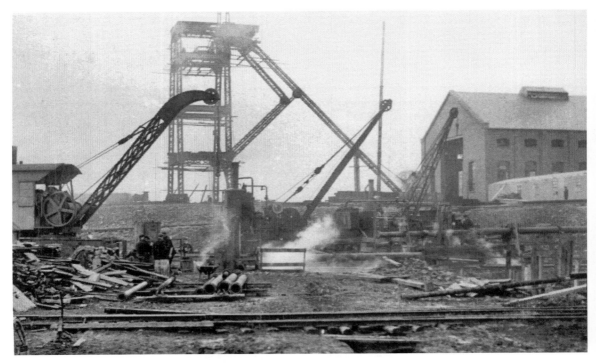

Above and below: The first turf was cut for Askern's colliery on 22 February 1911, and some time was then spent creating a link with the Lancashire & Yorkshire Railway lines at a point near Norton Station. The *Don. Chron.* (*op. cit.*) stated: '... in a direct line with the boring apparatus; a hord of burly navvies are at work with their picks, their shovels, and their barrows. They are constructing the embankments over which a railway connection will be made ...' The site chosen for sinking the shaft came as a shock to Askern villagers, for instead of being somewhere on the levels between Askern and Moss, the headworks were set up by the picturesque road to Campsall, close to Askern Spa and within a stone's throw of the hydro and the famous pool.

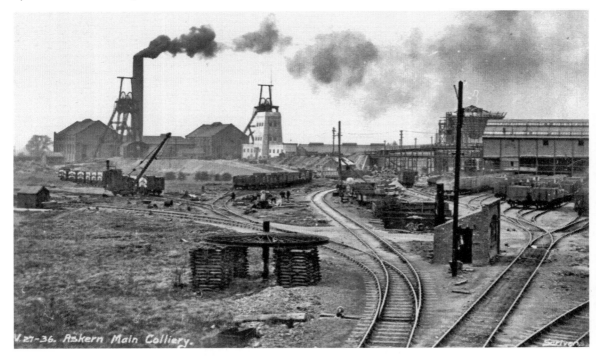

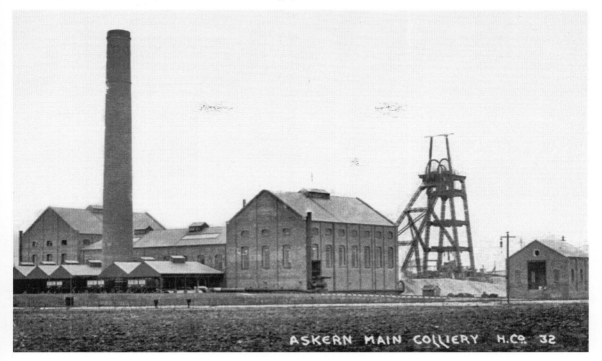

Above and below: Sinking operations were commenced in Askern's No. 1 shaft on 5 December 1911. From the outset they had difficulties with water, which had been anticipated, but it turned out not to be as bad as at Bullcroft and Thorne. A powerful pumping plant was installed to deal with the expected tremendous influx of water, which sometimes reached 4,000 gallons per minute! On Saturday morning, 14 September 1912, the Barnsley seam was reached at a depth of 565 yards and the coal was found to be of excellent quality. This made the fourth occasion on which the Barnsley seam had been tapped in the Doncaster district in little over two years – after Maltby in June 1910, Edlington in July 1911 and Bullcroft in December 1911.

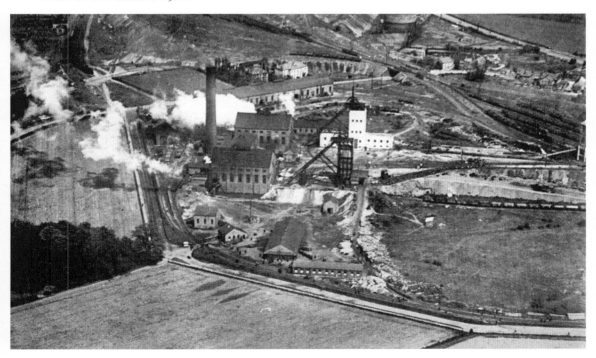

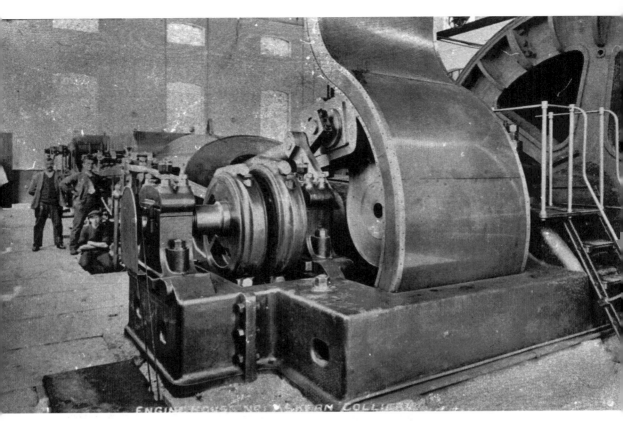

Above and below: Both these pictures taken by Bramley, Cross Gates, Leeds, illustrated a *Doncaster Chronicle* article titled 'Askern's Awakening', which appeared on 6 September 1912. The top picture shows the engine house, the bottom one the air compressor. The newspaper commented: '... it may be pointed out that the whole of the permanent plant is completed, with the exception of the screens. These are now being fixed into position by Messrs Plowright Bros of Brampton, Chesterfield.'

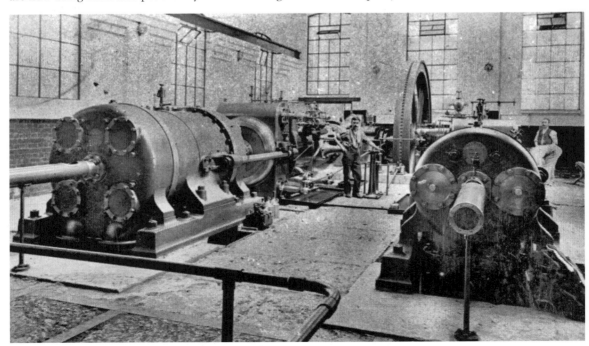

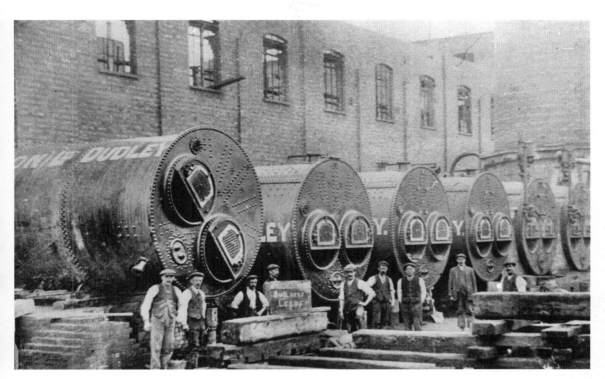

The *Don. Chron.* of 6 September 1912 mentioned that the whole of the work in the colliery shafts had been done in the most efficient manner (day work) under the superintendence of Sam Howard. 'He has employed the best men in the country he could lay his hands on ... the surface work was carried out by Messrs Charles Baker and Sons of Chesterfield ... the pit is equipped with the latest and very best machinery,' said the newspaper. The above picture shows boilers being installed.

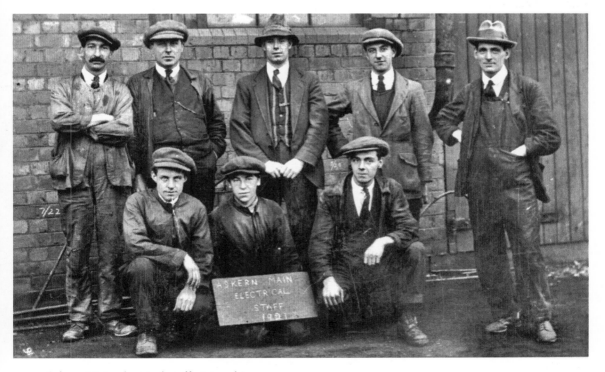

Askern Main electrical staff pictured in 1921.

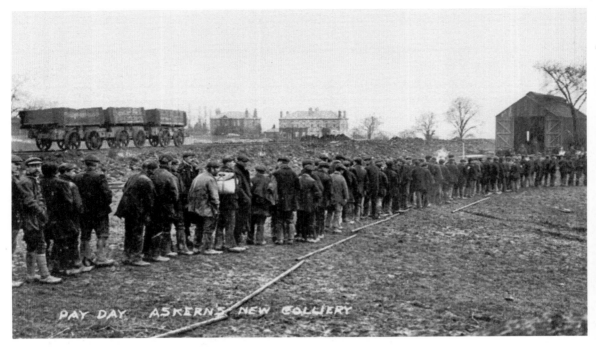

Pit sinkers and navvies are lined up, ready to receive their wages at Askern Colliery. The photograph was reproduced in the *Doncaster Gazette* of 24 March 1911.

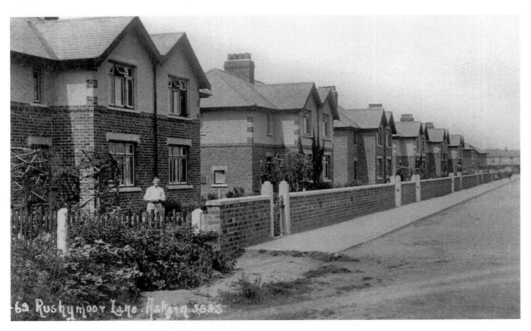

Under the heading 'Housing at Askern', the *Don. Chron.* of 10 October 1913 wrote about the overcrowded state of Askern, the scarcity of houses, the unsatisfactory class of houses that were being erected in the Askern model village, the high rentals, and the fact that builders would not erect a sufficient number of houses to meet the demand. A Mr Stubbs, chairman of the Askern Parish Council, stated that, to his mind, one of the reasons the houses were not being erected more rapidly was the recent introduction of a town planning scheme by the Doncaster Rural District Council, which was restrictive and unfavourable for house builders. The above view shows Rushymoor Lane, Askern, shortly after being built.

Above and below: The Askern Coalite Chemical Plant is seen in 1982 (top) and 1988 (bottom). *Wikipedia* states that Coalite is a brand of low-temperature coke used as a smokeless fuel. The title refers to the residue left behind when coal is carbonised at 640 degrees Celsius. It was invented by Thomas Parker in 1904. Coalite was manufactured by the Low Temperature Carbonisation Company, which established a manufacturing plant at Buttermilk Lane, Bolsover, Derbyshire, in 1936. At the time it was the largest of its type in the world. Plants were also opened later in Askern and Rossington, and at Grimethorpe in South Yorkshire. In 1948 the company changed its name to the Coalite Chemical Company to reflect the diversified nature of the business. The solid fuel side of the business began to shrink in the '80s. The Askern works closed in 1986.

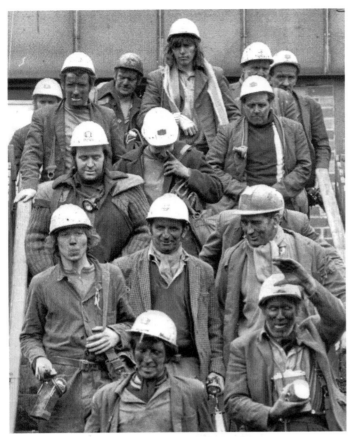

Left and below: A strike was called by the NUM in February 1974 and lasted four weeks. A state of emergency and a three-day working week were declared. The Prime Minister, Edward Heath, called a general election hoping that the electorate would support the government's attempts to deal with the deteriorating industrial situation, but the Conservative Party was defeated. The new Labour government reached a deal with the miners shortly afterwards. Askern miners are seen in both pictures on 11 March 1974 after returning to work.

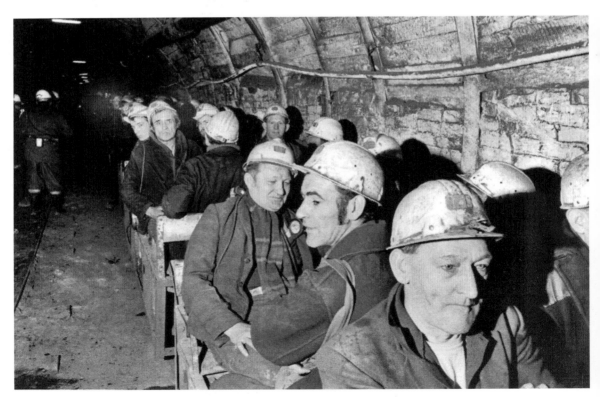

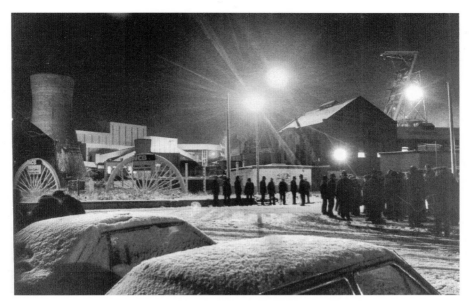

Askern Colliery early on 7 January 1985 as police and pickets await the arrival of a 4 a.m. workers' bus. The miners eventually returned to work on 5 March 1985 after calling the strike off two days earlier at a special NUM Conference.

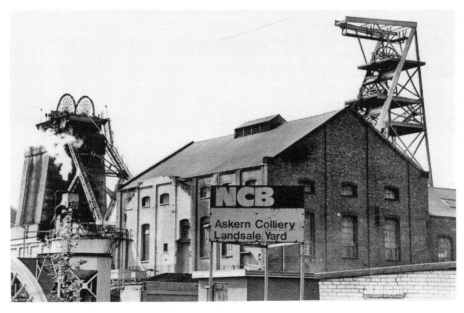

Throughout its lifespan Askern colliery struggled against geological conditions. Initially, it was intended that Askern should be a large pit, like Brodsworth, but it soon became apparent after coal production began in the Warren House and Flockton seams that the shafts were sunk in a heavily faulted area. A series of boreholes made around the area after nationalisation in 1947 showed that far fewer difficulties should be encountered once a way was driven through the second Pollington fault. This was proved correct, and two drifts of about 1,500 yards were driven to serve the Pollington districts to the north-west. The Flockton seam was abandoned in May 1965, after a final bid to make it worthwhile. The *Don. Star* of 22 November 1991 recorded: 'In September 1985, 900 men at the colliery produced 14,500 tons of coal in a week. A new coalface was opened in 1987 in a £7 million investment which featured the world's biggest pit props, costing £23,200 each and a high speed underground rail route.' Askern Colliery is pictured here on 1 July 1985.

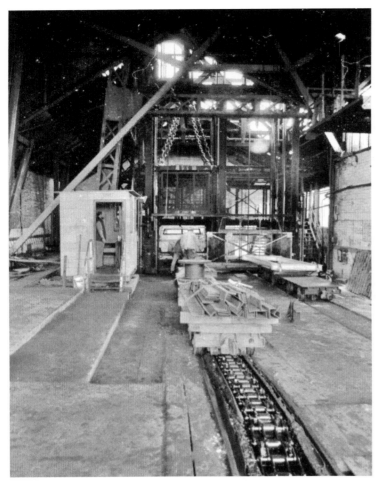

Left and below: On 22 November 1991, the *Don. Star* was headlined 'Askern Pit to Close in Weeks' and informed readers that the colliery would close 'next month' with the loss of 460 jobs. British Coal's Selby Group Director, Alan Houghton, told union representatives at a reconvened review meeting that the colliery had lost over £32 million in the last eleven years and only made an annual profit twice during that period. NUM branch secretary Pat Hewitt said: 'We knew there was a threat of closure but we were still hoping it would not happen. Everyone has tried very hard and the pit was doing well. We were still hopeful.' The last shift clocked off on 20 December (*Don. Star*, 7 January 1992). All the buildings on the site were cleared in 1993. These two views of Askern Colliery were taken in around 1992.

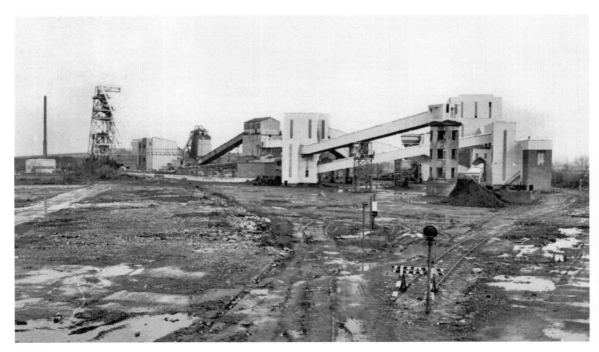

Barnburgh Colliery

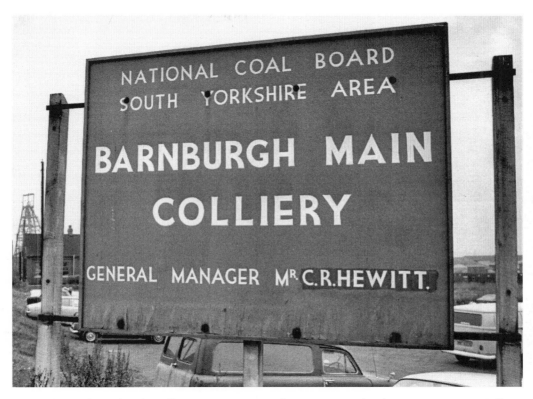

The sinking of Barnburgh Colliery was commenced in June 1912 by the Manvers Main Colliery Company of Wath-upon-Dearne. The sinking reached the Barnsley seam at 560 yards at No. 6 pit on 28 May 1914 and at No. 5 pit on 13 June 1914. Sinking was continued in the Parkgate seam at 757 yards which was reached in No. 5 shaft on 28 February 1915, and in No. 6 shaft on 3 March 1915. The photograph of the Barnburgh Main Colliery sign was taken 22 October 1976.

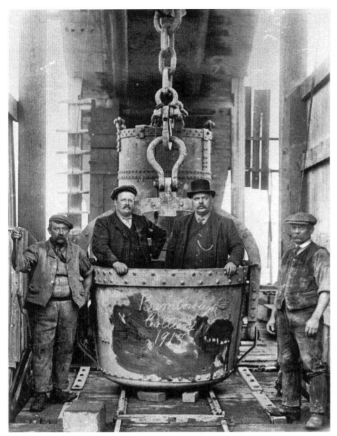

Left and below: W. A. Pickersgill, in his article 'Cementation in Shafts, Dams and Stoppings' from the *Transactions of the Doncaster & District Mining Society*, August 1937, records that no special difficulties were encountered in the sinking of the Barnburgh shafts 'which were lined throughout with 9" brickwork except the part between the surface and the Shafton seam ... The largest amount of water encountered in the sinking was only 20 gallons per minute ... The maximum rate of sinking was 18 yards in a single week in No. 5 shaft and 21 yards in No. 6 ... The number of sinkers on each shaft was 20 in No. 5 and 18 in No. 6 ... Hardy Patent Rock Drills were used to drill the shot holes which were charged with gelignite tamped with water in the ordinary way.' The new colliery was adjacent to the Dearne Valley Railway, to which it was connected, but in 1924 a private line was constructed between Barnburgh and the Manvers complex.

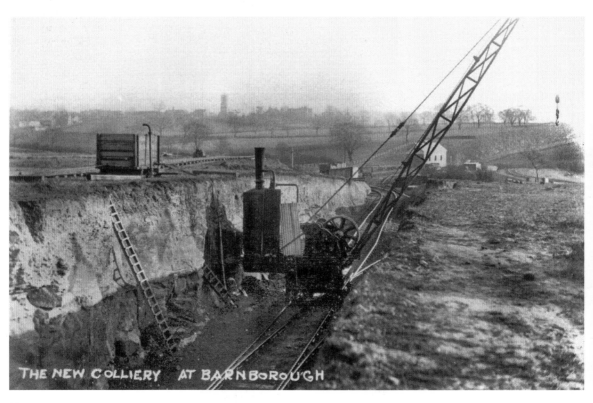

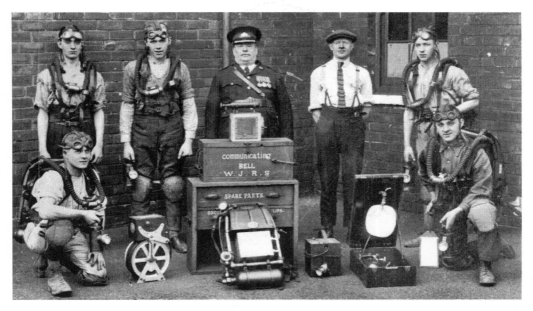

Above and below: A collapse in the Parkgate seam down Barnburgh Main Colliery shortly after 6 p.m. on Friday 24 April 1942 resulted in seventeen men and youths being trapped, some for nearly three days. Four of them died. There was danger immediately after the accident, as the disturbance released a quantity of gas and ventilation of the section was impeded. There was a risk of the trapped miners being asphyxiated, but the rescuers diverted as much air as possible towards the affected area, and in the end thirteen of the trapped men and boys were rescued. Over forty hours elapsed before the first batch of eight – six men and two youths – could be released. Those to lose their lives were Alfred Lazenby, aged twenty-five, of Goldthorpe; Charles Cope, forty, of Mexborough; George Southwell, thirty, of Bolton; and William Rodgers, twenty-six, of Mexborough. The picture above depicts the Barnburgh Main Rescue Brigade in 1929. The picture below depicts the Barnburgh Main Colliery Rescue Team No. 2 in 1948; they are from left to right: R. Bunting; A. Hunter, Vice-Captain; A. Cadman; J. Triffitt, Captain; J. Lawson; W. Ganley; J. Webb, Superintendent; H. Hepplestone, Assistant Superintendent.

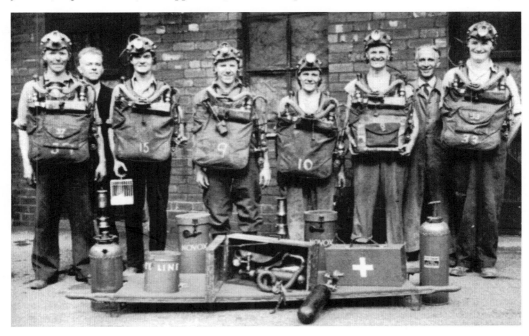

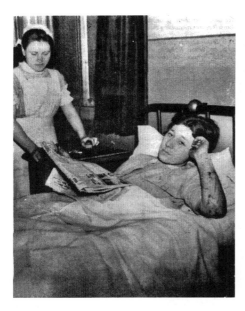

The picture on the left shows Leslie Thompson recovering in Mexborough Montagu Hospital after being rescued from the pit.

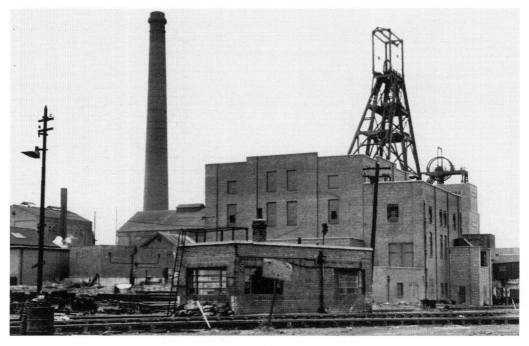

Barnburgh Main pictured on 26 June 1957, when an explosion at the colliery caused the death of six underground workers. The explosion was caused by firedamp ignited by a 'flash' from a damaged cable. The official report on the disaster gave an overview of the colliery workings: 'There are two shafts, No. 5, the upcast, being 18 feet in diameter and No. 6, the downcast, 16 feet in diameter. The shafts are sunk to the Parkgate seam, 755 yards deep, intersecting the Newhill seam at 340 yards and the Barnsley seam at 508 yards. Both shafts are regularly used for winding men and material. The mine produces nearly 4,500 tons of coal per day with 2,040 men employed underground and 379 on the surface ... At the time of the explosion there were seven producing districts in the seam, one single and six double units, with a total length of face of 1,336 yards.' In June 1968, twenty miners at the colliery were treated for shock, bruises or cuts when a paddy mail carrying forty men underground was derailed. In November 1972 a miner died at the pit following a roof fall.

On 6 September 1963, thieves were foiled in their bid to snatch a £50,000 colliery payroll because of a tightening in Coal Board security. Until some weeks earlier, the weekly payroll for Barnburgh Colliery had been carried in a van which was attacked by a four-man gang in a lonely lane. But because of fears of such an attack, an armoured van was brought into use and the old payroll van was used to carry pay clerks to the pit for the weekly payout. The move paid off when the thieves picked on the old van. They ordered the occupants out and ransacked the van before driving off empty-handed at high speed.

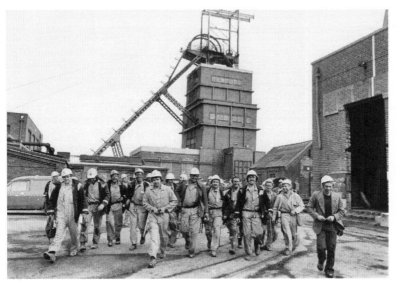

On 27 October 1976 the *Sheffield Star* recorded that the bulk of the 1,200-strong Barnburgh workforce travelled from Bolton-on-Dearne, Goldthorpe and Upton, near Pontefract. The Upton men were transferred to Barnburgh when their colliery was closed after a history of underground troubles. On 14 May 1980, the *Sheffield Star* said that space-age mining techniques helped Barnburgh Colliery smash their weekly output record and produce more coal in the previous twelve months than they had done over a decade. One of the main factors in helping to improve output 'was a new coal cutting machine which had a nuclear sensing device for steering'. Colliery manager Barrie Rason said: 'The team spirit at the pit is now tremendous. The turnabout in production came after we altered the way we mined the coal and men have responded to the incentive bonus scheme.' The photograph of miners at the colliery was taken on 8 May 1980.

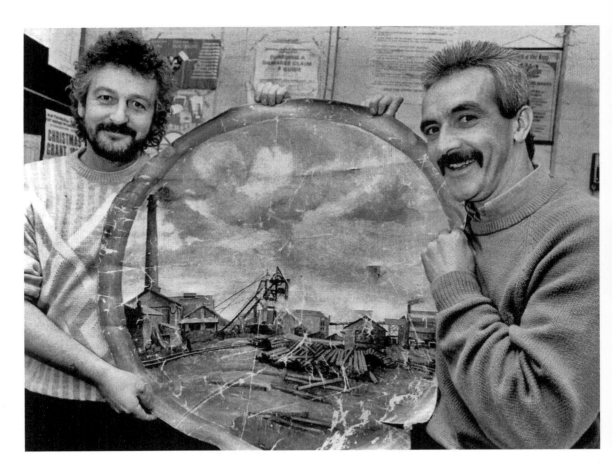

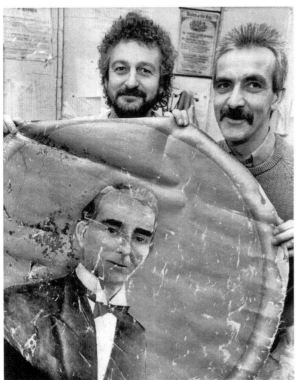

Above and left: Barnburgh Colliery NUM Branch President Bob Burnett (left) and treasurer Bill Cook are pictured with the centrepiece of the first ever Barnburgh Main NUM Branch banner. One side of the banner centrepiece shows former miners' leader and Labour politician Tom Williams (1888–1967), who later became Lord Williams of Barnburgh, and the other side shows an early view of the colliery. The banner was salvaged by a worker when an old building at the pit was demolished. These pictures were taken in December 1988.

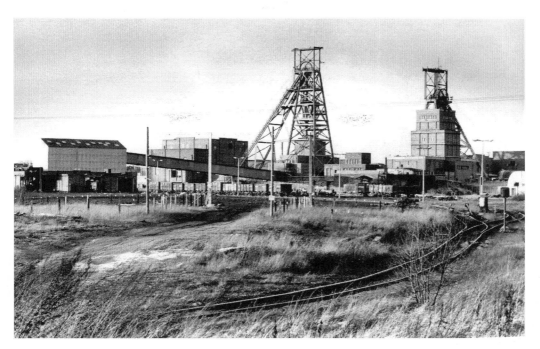

Barnburgh Colliery pictured on 3 August 1982.

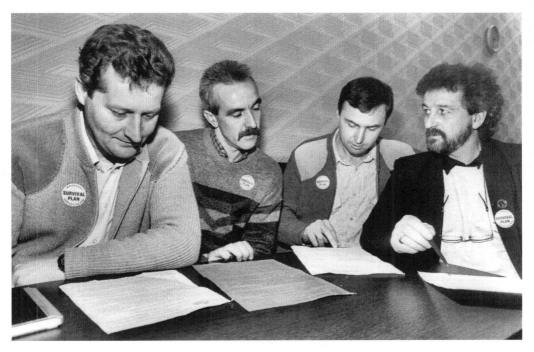

Barnburgh Colliery NUM Branch officials (from left to right) Clarrie Hardeman (delegate), Bill Cook (treasurer), Dave Thomas (secretary), and Bob Bennett (president) discuss the crisis at the colliery during February 1989. In subsequent weeks they put forward a survival plan which they hoped would keep the colliery alive. Unfortunately, this was in vain and the shock announcement of the closure of Barnburgh Colliery and the Manvers Coal Preparation Plant later in the month united the community in a bitter condemnation of British Coal's decision. It was particularly disappointing when the workforce had constantly broken production records at the pit, including the national record some weeks earlier.

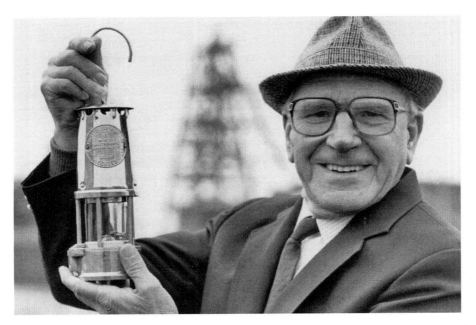

Pit Deputy Albert Cadman, seen here aged seventy-two, played a vital part in the rescue of men trapped underground at Barnburgh Colliery after the 1942 roof fall. Ignoring warnings, he crawled on his stomach to reach five of the trapped men. One was dead, but he helped drag the others to safety. To recognise his heroism he was presented with a miners' lamp in a ceremony organised by NACODS in March 1989.

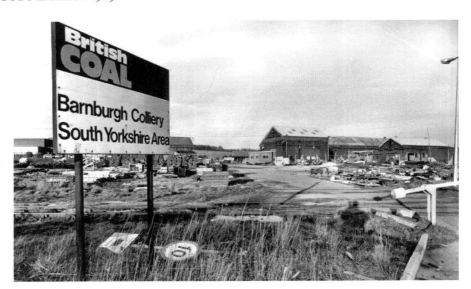

In a statement after the Barnburgh closure announcement, British Coal said: 'We want to make it clear it is no reflection on the workforce at Barnburgh. Many of the miners at Barnburgh were "refugees" from other colliery closures.' Barnburgh Colliery closed on 26 May 1989 (*Don. Star*, 9 June 1989) with the loss of approximately 750 jobs. The newspaper said on 24 July 1989 that coal chiefs 'had their wrists slapped' over the way they axed Barnburgh Colliery: 'The criticism comes from the coal industry's independent review body which has accepted a complaint from the National Union of Mineworkers ... British Coal put pressure on Barnburgh pitmen to accept the closure by setting a deadline for redundancy applications which was ahead of the review meeting. Workers abandoned the fight, faced with the threat of losing enhanced pay-offs if they did not apply.' Much of the former colliery site is now a country park.

Bentley Colliery

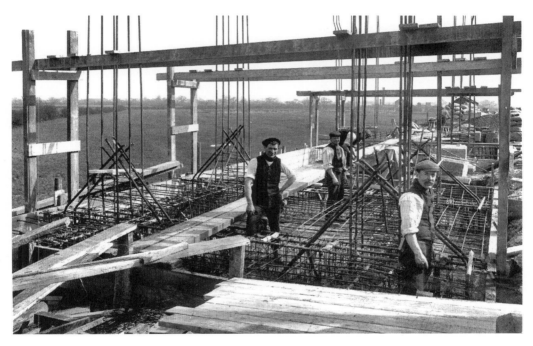

Barber Walker & Company commenced a proving borehole near Bentley Mill in 1887, but owing to the nature of the strata bored through, the attempt was abandoned. In 1895, a further attempt was made by boring at the corner of Daw Lane Plantation and the rich Barnsley seam was proved at a depth of 615 yards. Negotiations with local landowners for working rights followed and sinking was begun in 1904. The No. 2 shaft was the first to be commenced, in 1905. The sinking of the upcast shaft was started in October 1905 and a depth of 50 feet was reached in December of the same year. It was decided to sink through the quicksand – believed to be only 50 feet thick – by lowering bolted cast-iron tubbing together with steel piles, grooved and tongued into each other, forming a complete circle round the outside of the bottom ring and sliding on the back of it. However, these operations proved unsuccessful and sinking was stopped, another attempt being made on 3 March 1906. On 6 November 1908, the *Doncaster Chronicle* noted: 'On Friday evening the pit sinkers at the Bentley Colliery were provided with dinner to celebrate the reaching of coal at both shafts, when there was an attendance of upwards of 300. The arrangements for the spread were admirably discharged by Mr Hildernby of the Bay Horse, Bentley, whose cuisine and general appointment met with the most cordial recognition. Dinner was served in a large marquee; lent by Messrs Cooper & Sons, Priory Place, erected in a field in Arksey Lane'.

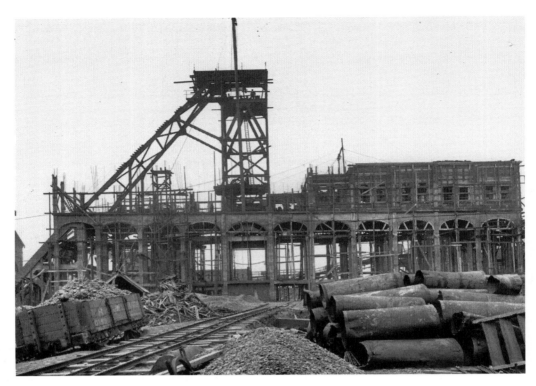

Above and below: During 1910–11, a 'heap stead' was erected at Bentley Colliery over the No. 1 shaft. The building was constructed of reinforced concrete – a new departure so far as colliery headworks in this country were concerned. Its adoption at Bentley was particularly due to the bad foundations upon which the pit was built, reinforced concrete being considerably lighter in proportion to its strength than anything else. A further advantage was that it would be more fire proof than headworks built in the ordinary way, with no timber being used. The construction was about 45 feet in height up to the level to which the tubs would be raised, and then there was another 14 feet of concrete work above that. Around 150 tons of steel bars were used in the construction.

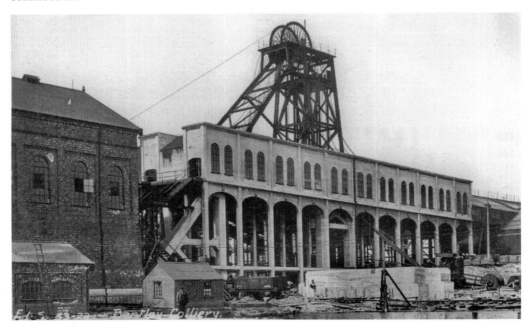

Right and below: The *Doncaster Chronicle* reported on 25 February 1910: 'When the first cartload of bricks was shot down early one morning in the place where the new Bentley now stands the lark was singing, the wild flowers were blooming upon the hedgerows and the rabbit and fox lurked in the adjacent woods. This was about six years ago ... Now one can purchase picture postcards showing how complete is the transformation scene which has been effected in much less than a decade ... The total employees of all grades at Bentley is about 1,000 of whom some 700 are employed underground. The mine is worked in three shifts, and the output averages at about 2,000 tons of coal per day ... It is impossible to enjoy the privilege of a walk round without being impressed with the fact that everything one sees is of the latest and newest pattern; the mine is an absolutely first class one in every respect.' The picture to the right shows miners at the pit top at Bentley, and below is a scene in Bentley during the 1926 strike.

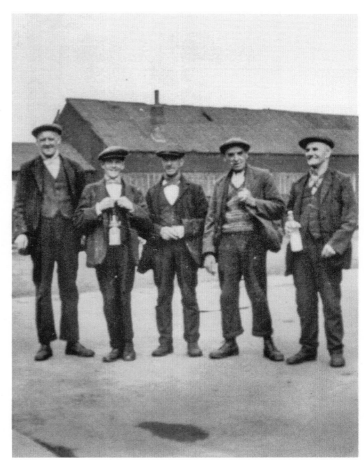

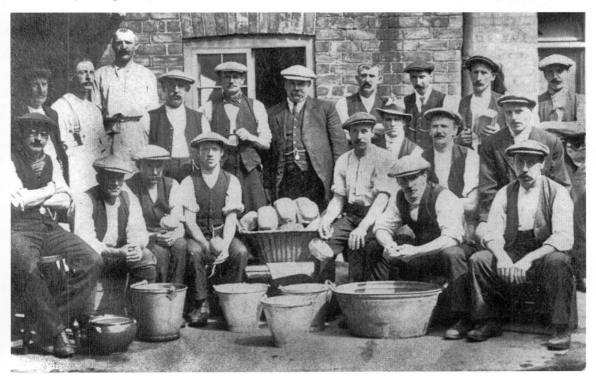

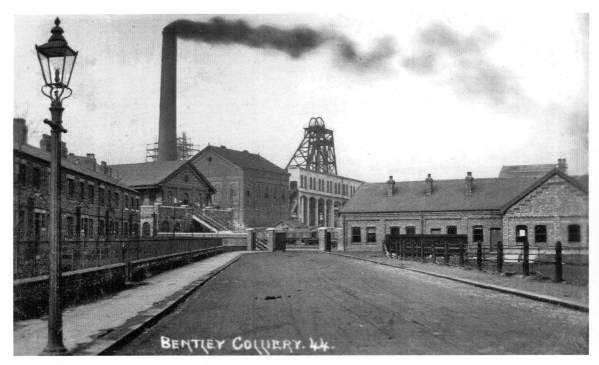

Above and below: In 1931 Bentley Colliery was one of the largest and best-equipped coal mines in South Yorkshire. However, on Friday 20 November it was the scene of the worst disaster that had taken place at any of the new collieries in the South Yorkshire Coalfield. The Bentley explosion, though less serious than that of Cadeby in 1912, was felt keenly by the inhabitants of Doncaster, inasmuch as it occurred on the very doorstep of the town. The first news of the calamity came through to Doncaster shortly after 6 p.m. on Friday in the form of alarming rumours. Nobody knew exactly what had happened beyond that 'there was something up at the pit'.

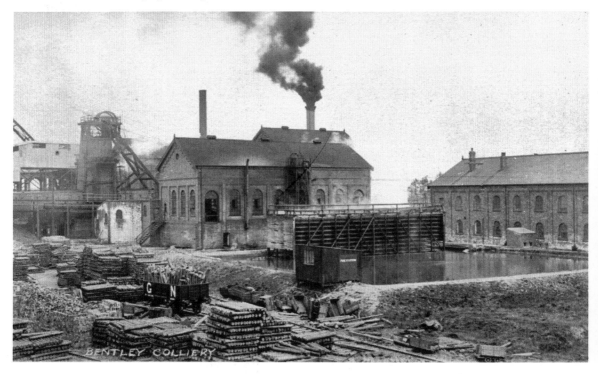

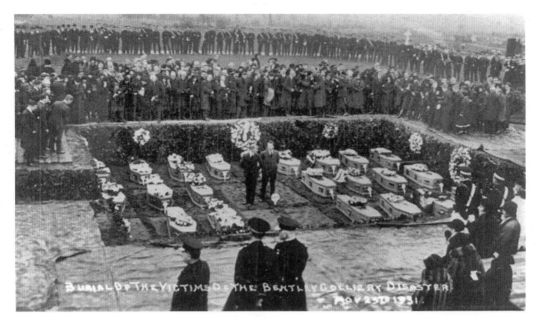

It was not until the early hours of Saturday morning that the full extent of the disaster became apparent. The first information was that one man had been killed and several injured. But after many of the injured had been brought out, the rescue parties commenced to bring out the dead, one after the other, at intervals of 20 to 30 minutes. Fortunately, the unique ventilation system isolated the outburst to one district, or the disaster, in human terms, might have been greater. In total, forty-three miners were killed instantly and four were injured, two of these dying later. King George V sent this message: 'The Queen and I are shocked to hear of the disaster which occurred last night at Bentley and send our heartfelt sympathy to the families of those who have lost their lives tragically.' The following Wednesday, 25 November, thirty-one victims of the disaster were buried together in one big grave at the Arksey Lane Cemetery amid unprecedented scenes of public sympathy. The coffins were borne to the grave on motor lorries in a long procession from the New Village Church at Bentley.

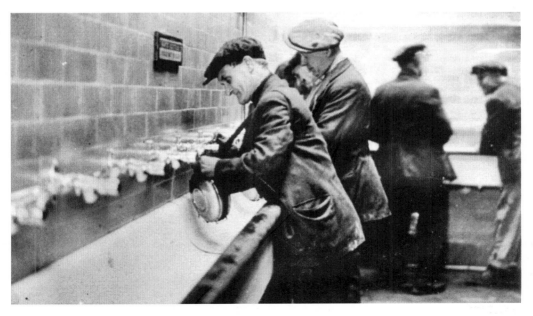

Filling water bottles at Bentley Colliery.

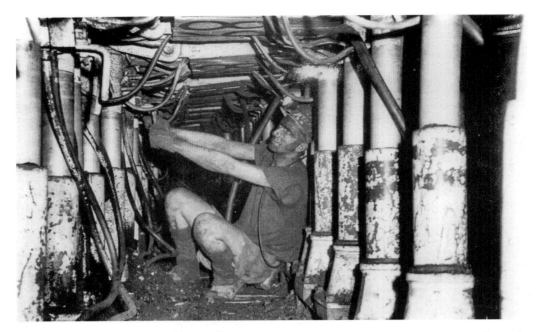

Above and below: These two pictures appeared in a brochure published by the NCB in the early '70s. The top picture carried the following caption: 'The freshly cut coal ... falls on to a steel conveyor running parallel to the full length of the face. Attached to the conveyor by hydraulic rams are the powerful roof supports [seen here]. Moved at the touch of a lever they [advance] forward, when the machine has passed, to support the newly-exposed roof and provide cover for the men working underneath.' For the picture below, the following information was provided: 'When the men descend the shaft at Bentley – 48 at a time – waiting in the pit bottom to speed them to the coalface about two miles away, is a mini train [seen here] called a "paddy" in the industry.' In the 1970s, output at Bentley was 14,000 tons per week with 920 men employed below ground and 280 men on the surface.

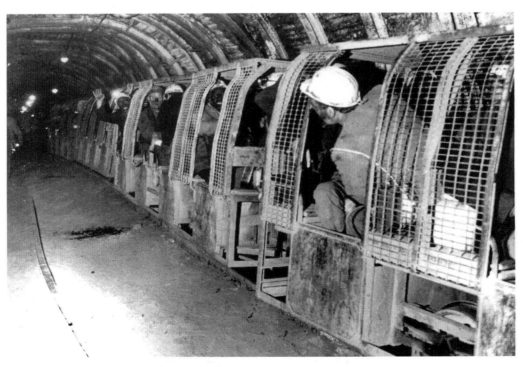

Right and below: At 4.55 a.m. on 21 November 1978 Bentley Colliery saw seven men dead and nineteen others injured, three of them seriously. A diesel-drawn paddy train ran into trouble on a sharp bend as it careered out of control for a distance of about 800 feet (244 m) on an incline dipping at 1 in 16. Three of its four coaches were derailed and men were thrown violently from their wooden seats as it crashed into the steel arched roadway supports. Some were trapped in tangled wreckage. The train was carrying sixty-five men who had been working in the Dunsil seam. Separate funeral services were to be held for the victims during the following week. Don Valley MP Dick Kelley joined a call in the House of Commons for an inquiry into the Bentley tragedy, to consider whether pit productivity deals had any bearing on the fall in safety standards. In the picture to the right, Bill Askew, chief engineer for the Doncaster area, is seen with a Godwin Warren arrester on 21 November 1978. This type of arrester was installed at collieries to stop runaway vehicles. The photograph below shows an ambulance leaving the colliery on the day of the disaster.

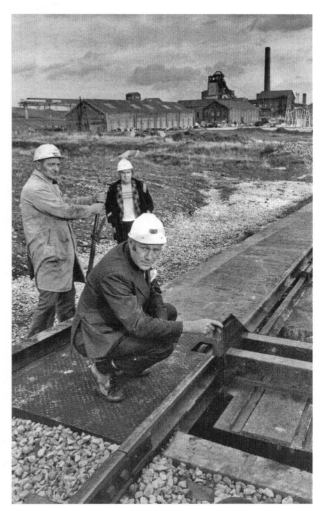

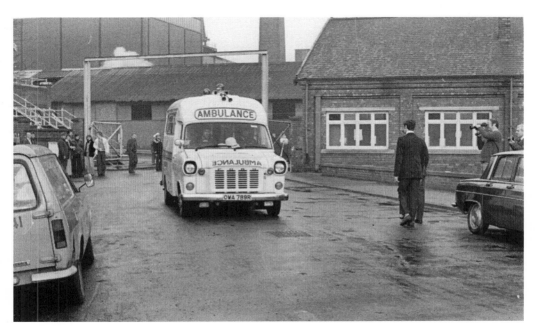

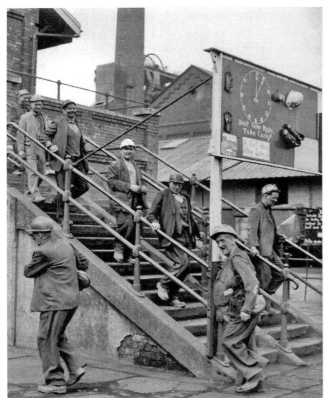

In March 1969, Bentley Colliery was in the news, held up as a striking example of a pit that had 'changed its ways'. Twelve months earlier, it was alleged the colliery was the 'sick man' of the area, torn by industrial strife and sorry holder of one of the worst records for disputes, and was under the threat of closure. But a year later, it was not merely a pit which came back from the brink but a pit in the top ten productivity bracket. The reduction of worked faces from nine to three was also said to have had great advantages in efficiency, for it meant that just one long conveyor belt – about three miles long – could be used to take coal direct from the face to the shaft. Furthermore, Bentley housed one of the area's two main training centres. The mechanisation training centre was the only one of its kind locally. During the 1980s No. 2 shaft was dropped to 830 yards to mine the Parkgate Seam, which pushed the colliery's annual output for a time to 1 million tons. Bentley Colliery miners are seen in March 1968.

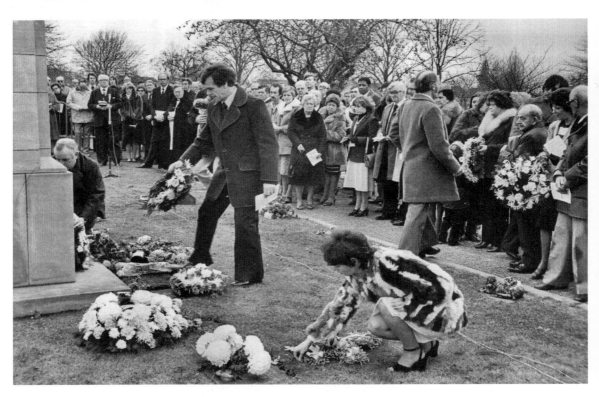

A combined memorial service in memory of the men who lost their lives at Bentley Colliery on 20 November 1931 and 21 November 1978 was held at Arksey Cemetery in November 1981.

On 1 December 1989, the *Don. Star* said it was thumbs up for the miners of Bentley Colliery, who were celebrating a hat-trick of output and productivity records. They set up a new weekly output best of 25,975 tonnes, which topped their last record of 24,617 tonnes by 1,300 tones. The 610 men also lifted their overall productivity record by nearly two thirds of a tonne per man to 7.85 tonnes per man, and they rounded off their record-breaking spree by achieving a new face output per manshift high of 30.11 tonnes, smashing a two-year-old record by more than three tonnes.

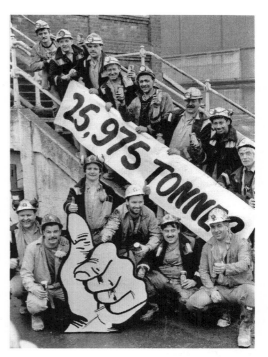

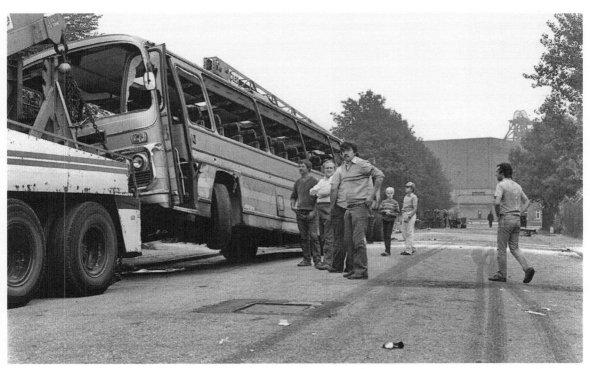

A smashed bus outside Bentley Colliery during the 1984/85 Miners' Strike. In October 1984, NUM officials at Bentley claimed a man who was going into work every day and breaking the strike was not a miner but a policeman. Jock Nimmo, Bentley NUM president, said: 'We know for a fact that this man is not a Bentley miner ... the Coal Board is hoping some of the lads will go in if they think somebody else is working, but we know our members better than that.' On 16 November 1984, the *Don. Star* reported that the NUM committee at Bentley Colliery had decided unanimously that it would not represent any of the thirteen miners who had gone back to work ever again.

The *Doncaster Star* of 16 November 1993 stated that British Coal's announcement to shut down Bentley Colliery was met with an air of sad inevitability within its community. Bentley vicar Bob Fitzharris commented: 'We are being held hostage to fortune by this evil [Tory] administration that worships the false god of the market place ... It is a sad and black day for Bentley.' Dennis Ashton, who had worked at the colliery for nineteen years, said: 'There is life in Bentley Colliery but the market is just rigged against us.' Wilf Gibson, who retired from the colliery in 1986, said: 'For a pit to close like that when it is producing coal like Bentley it is just wrong – I can see no reason for it. At the end of the day we have got a pit that is workable.' Other miners and former colliery workers said they were bitter about the way they had been treated by the government. Bentley Colliery is seen here on 5 December 1983.

During late 1994 and early the following year the Bentley Colliery buildings were demolished. Redevelopment work started on the site during the latter half of 1998 and the area now forms part of the Bentley Community Forest. The above photograph shows the first phase of the redevelopment taking place. On www.forestry.gov.uk, it is stated: 'Bentley Colliery was an important focal point for the communities surrounding Bentley, but the closure of the pit in 1993 presented an opportunity to transform the site into a resource for all of the community to enjoy.'

Brodsworth Colliery

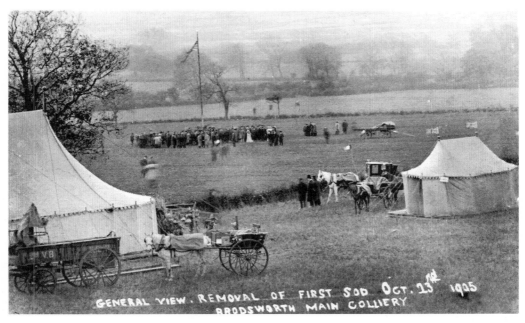

GENERAL VIEW. REMOVAL OF FIRST SOD OCT. 23rd 1905
BRODSWORTH MAIN COLLIERY

On 23 October 1905, a group assembled in a Pickburn field on the Brodsworth Estate. They were there to witness the cutting of the first sod at Brodsworth Colliery by Brodsworth Estate owner Charles Thellusson. The pit was sunk jointly by the Staveley Coal & Iron Co. Ltd and the Hickleton Main Colliery Company Limited, and they leased 6,000 acres of coal-bearing land from Thellusson. Until the early part of the last century, the mining operations on the great South Yorkshire Coalfield had been confined to the planting of collieries on the outcrop of coal measures extending from Conisbrough to Penistone. In the middle of the area was Barnsley, which for many years had been regarded as the coal metropolis of the district. Owing to the exhaustion of the principal profitable coal seams at the comparatively shallow depths in that neighbourhood, it became necessary to carry on operations by deeper sinkings to the east. Brodsworth was an example of this.

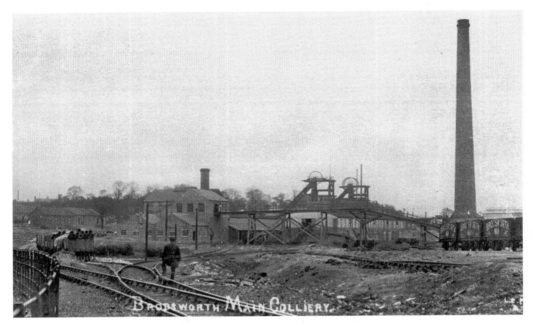

Above and below: The *Don. Chron.* of 25 October 1907 said that W. Bunting acted as manager of the Brodsworth sinking operations, with Mr Parker Shore as engineer in charge. The Barnsley coal seam was reached in November 1907 at a depth of 595 yards. On 15 April 1910 the newspaper gave a description of the workings: 'One thing which the visitor to Brodsworth notices is that, with the exception of the downcast engine house, and two huge chimney stacks, the pithead frames and the whole of the colliery buildings are constructed of wood. [This is because at] the commencement of operations it was decided to take out the shaft pillars, and allow the ground to settle. But when coal was found at a less depth that was expected, the pillars were allowed to remain. The downcast engine house was built at a later date. Coal is wound from both shafts, each of which is 20ft 6in in diameter in the clear. From the bank to the centre of the pulleys the wooden frames are 52ft high. In the downcast shaft, there is a double deck cage, which will carry three trams to each deck; the upcast shaft has a single deck cage for three trams. With the two shafts working about 6 tons of coal per wind can be brought to the surface.'

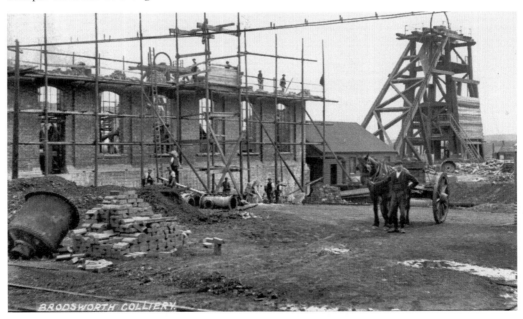

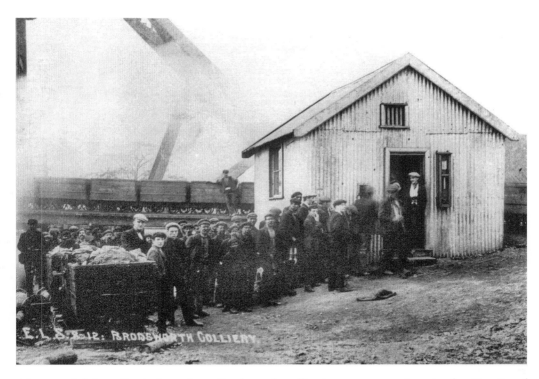

Above and below: Particulars about Brodsworth colliers' wages were given in the *Gazette* of 7 August 1914: 'Those of the surfacemen varied from 24s, or 25s up to £2 a week, and down the pit they received from 7s 6d a day in some cases a little less or just under £2 a week, up to £3 a week. About 20 per cent of the men were surfacemen. During the last eighteen months the colliery had employed 200 to 300 more men, about 2,500 being employed at the present time.'

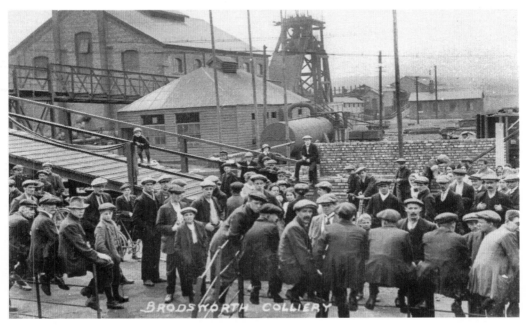

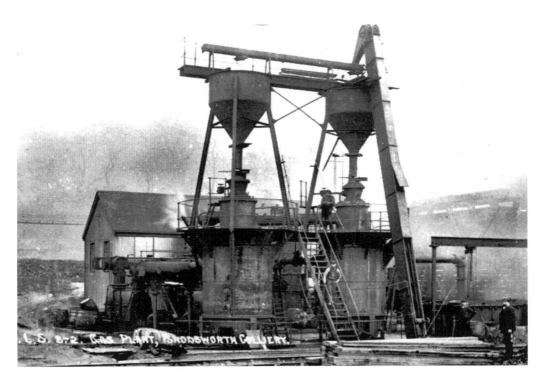

The *Don. Chron.* of 14 April 1910 gives details of a gas plant at the colliery: 'The gas producing plant is of an interesting character and is worked on the Mond system. The plant is arranged for continuous running, is simple in construction, and so designed that a minimum amount of labour is required for its operation. The system prevents waste, and dispenses with the necessity of storing gas. Remarkable to relate, after lying idle for a fortnight or three weeks, these gas producers can be got in motion within twenty minutes.' 'The Gas Plant, Brodsworth Colliery' was taken by local postcard photographer Edgar Leonard Scrivens.

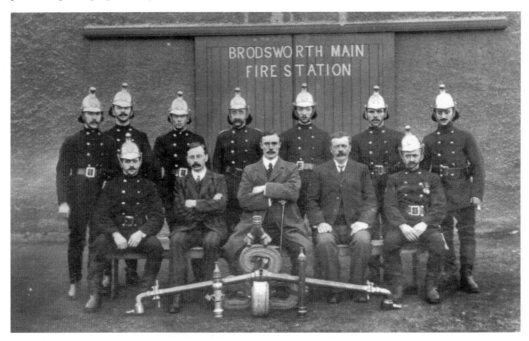

Members of Brodsworth Colliery Fire Brigade.

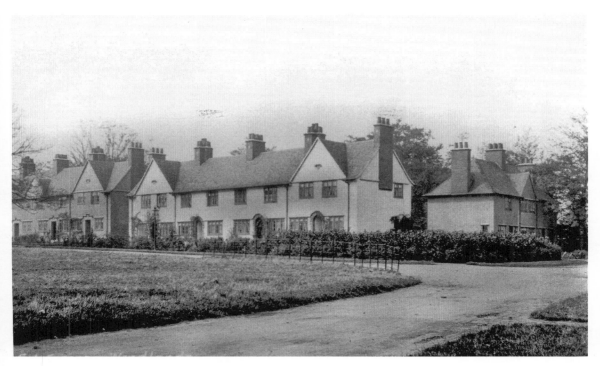

Above and below: Woodlands, depicted in both pictures, was designed and built in the early twentieth century by Percy Bond Houfton as tied cottages for the miners of the neighbouring Brodsworth Colliery. In an era of model villages such as Saltaire, Port Sunlight and Bournville, Woodlands, with extensive open spaces, many different designs of houses and overall living conditions superb for their time, possibly represents the height of the model village movement. The *Don. Chron.* of 15 April 1910 added the following details: 'There are five types of houses, the rents of which vary from 5s 6d per week to 6s 3d ... the main avenue of the village is 120ft wide, and has grass margins, along which trees will be planted to form an avenue. From this main thoroughfare roads radiate in various directions. The houses are well equipped and there is [ample] garden and air space.' The whole of the village is now a conservation area. The bottom picture shows soup kitchens at Woodlands during the 1920s.

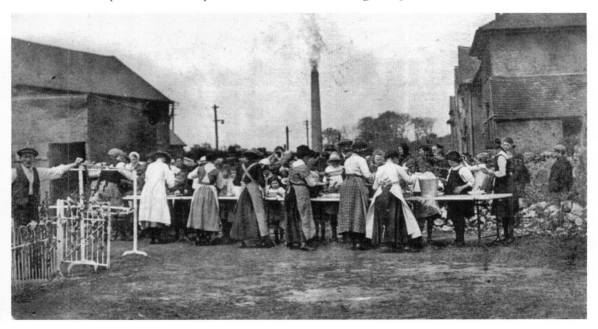

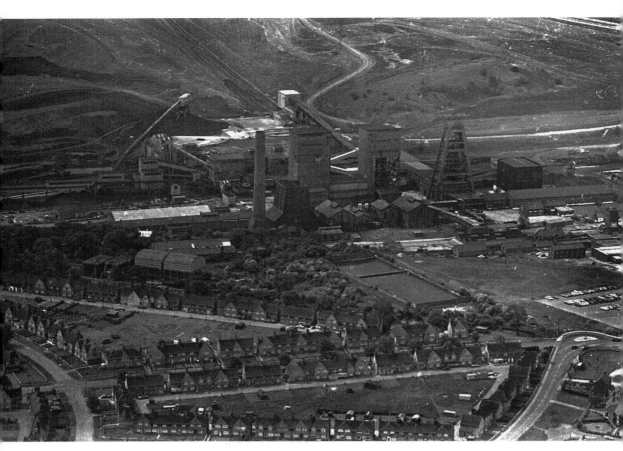

The Brodsworth Colliery shafts were deepened to the Parkgate seam commencing in 1920. The seam was reached in December 1921, at a depth of 814 yards. It was 4 feet 7 inches thick with a rock roof and strong stone floor. The shaft sides were secured with brick lining. Number 3 shaft was commenced in 1923 and reached the Barnsley seam, which was its limit, in July 1924. The colliery was served by three railways, the Hull & Barnsley, the Great Northern and the Great Central, being situated some two miles from Adwick and Carcroft station. At the start of April 1932, Brodsworth Main Colliery Company gave notice to 230 employees. More job losses were expected in subsequent weeks, and the dismissals covered all grades of workers. The management of the colliery said the reasons were attributable to the depressed condition of the coal trade. Among the men to go were several who had reached seventy and who had been retained largely in recognition of their long service to the company. On 13 January 1960, the *Sheffield Telegraph* mentioned that coal from Brodsworth was supplied for the heating of Buckingham Palace. By the end of the decade Bullcroft Colliery at Carcroft had been merged with Brodsworth. This aerial view of the colliery was taken in around 1975.

Opposite below: A roadheading machine at Brodsworth Colliery, seen on 5 February 1981.

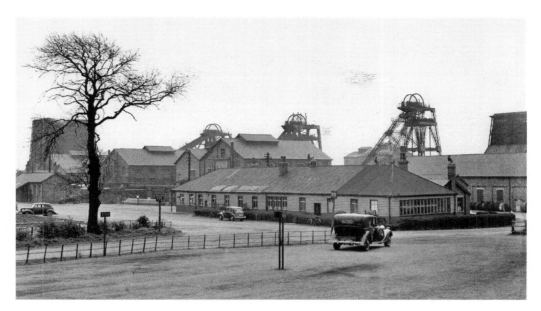

Coal Board boss Ian MacGregor was pelted with eggs and flour bombs thrown by about 100 miners from throughout the Doncaster area when he visited Brodsworth Colliery (seen above) on 2 February 1984. NUM branch secretary Jack Parry said the demonstration was against the government's choice of a seventy-two-year-old American to run an industry 'he has no affinity with'. During the visit Doncaster miners were branded as inefficient by MacGregor, who said the area had a long history of poor performance. Jack Parry instantly responded by saying: 'It surprises me that a man who has no involvement with mining can criticise the performance of miners. There are reasons why there had been a fall in production in recent years. Lack of investment is causing many of the problems.'

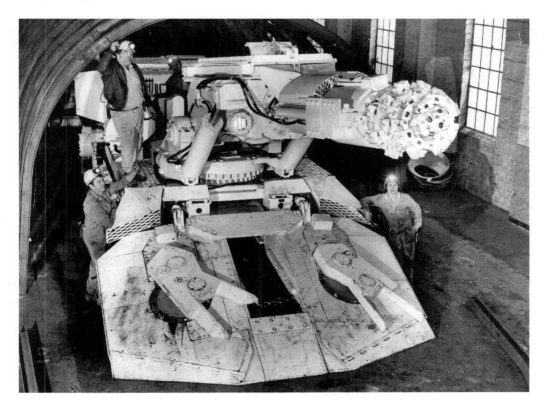

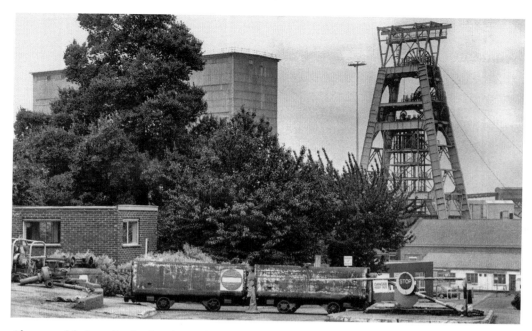

Above and below: In the *Brodsworth Review Special* of May 1990, it was stated: 'As you know at the Brodsworth reconvened review meeting on May 2nd, the Director said we must be making a profit on a week to week basis by the next review meeting in July or he will recommend closure in September.' Doncaster MP Mick Welsh moved an early day motion on 10 July 1990: 'That this House condemns British Coal for its decision to close Brodsworth Colliery in South Yorkshire, with a loss of 700 jobs in an area of over 10 per cent unemployment; notes that this pit has had investment of over £5 million in new face equipment this year, would be making a profit within the next two months and that there are over 10 million tons of workable coal at this pit; and therefore calls upon the Secretary of State for Energy to urgently meet the Chairman of British Coal and instruct him to have another look at the situation at Brodsworth Colliery before locking underground forever 10 million tons of the country's coal.' The colliery closed on 7 September 1990. The top picture shows the colliery in September 1990; the bottom one shows the Brodsworth winding gear being flattened on 5 March 1992.

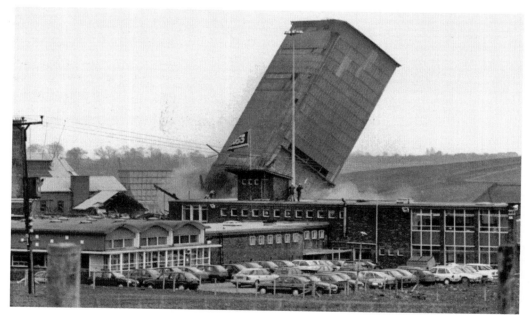

Bullcroft Colliery (Carcroft)

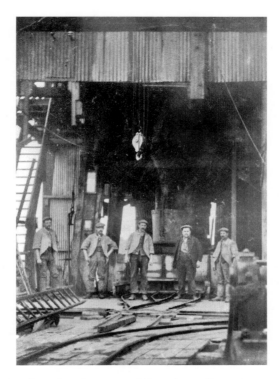

The countryside was stirred on the afternoon of Saturday 9 December 1911 by the strident calls of half a dozen buzzers. It was the way of announcing that coal had at last been reached at the Bullcroft Colliery sinkings, at a depth of 657 yards. The coal was beneath the estates of Major Anne, Mr Cooke-Yarborough, and other local landowners. Sinking operations began in May 1908, and water was soon encountered. At a depth of 70 yards the rush of water was so great the work had to be abandoned while steps were taken to overcome the difficulty. The strongest pumps seemed useless, so the freezing process worked by the Germans was given a trial. The waterlogged ground was frozen to a great depth by means of chemicals, and sinking then proceeded. As soon as sinking had passed the danger zone the shaft was encircled by an iron casing and then the ground was thawed, but the casing held back the water as anticipated. This work took over a year, and it was not until November 1910 that the shafts were pumped dry and further sinking could be resumed. At first progress was slow owing to the hardness of the frozen ground, but by March 1911 the workers had sunk beyond its range, and from that time everything had gone like clockwork. The coal reached on that Saturday in December 1911 was the Barnsley Seam, and it was 9 feet thick. The picture was taken at the time of sinking Bullcroft No. 1 shaft and a hoppet or ladle or kibble may be seen in the background. Walter Henry Stones has been identified as one of the men in the group.

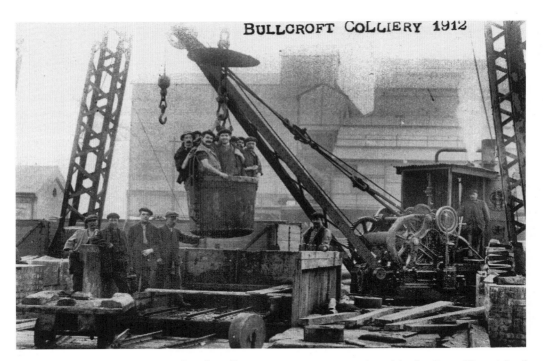

Above and below: Scenes at Bullcroft Colliery in 1912. It was mentioned in the *Don. Chronicle* of 16 May 1913 that all the employees at Bullcroft Colliery engaged in the manipulation of coal, both underground and on the surface, numbering in all about 1,800, have to become trade unionists. The usual procedure of stopping the contributions from the wage was carried out. 'This method of procedure is becoming more and more favourable to the officials of the Union, and if the fight for unionism becomes general throughout Yorkshire, as a result of the agitation that is at present going on, this method will no doubt become general.' The newspaper also added: 'For the past 15 months coal has been drawn out from the workings, 680 yards below.'

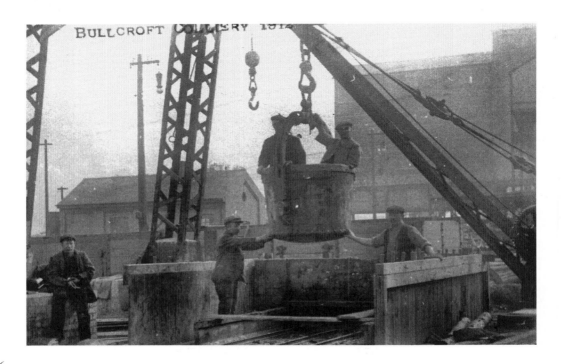

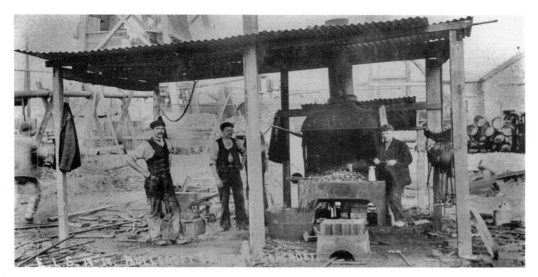

By 1913 there were about 1,800 hands employed at Bullcroft, largely drawn from the mining districts of Derbyshire and Nottinghamshire. The output of the colliery averaged 18,000 tons per week. 'It is stated that it is by no means working to its full capacity, and that in time a much larger staff will be employed,' reported the *Don. Chron.*, 16 May 1913. In the early stages of the pit's operation, the colliery company recognised that the miner was always an enthusiastic lover of sports and lent its support to the Sports and Pastimes Association. This was for the benefit of all the employees and each of them contributed an amount per week towards providing various kinds of sports. The photograph probably shows the first blacksmith's shop at the colliery. Note also the wooden headgear in the background.

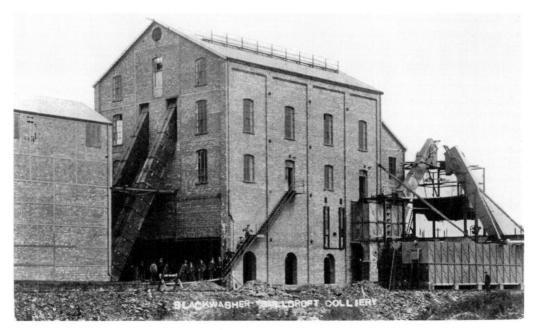

Slackwasher at Bullcroft Colliery, Carcroft. The *Don. Chron.* of 14 December 1911 stated that since the sinking commenced 'there had not been a single serious accident – all the more remarkable bearing in mind the unexampled danger and difficulty of dealing with a water problem'. The managing director of the mine was Mr Humble and the engineer was Mr De Seifreyd, a brilliant young Pole since whose coming the work had proceeded without a hitch. By 1913 the Bullcroft shafts were deepened to 682 yards to meet the Dunsil coal seam.

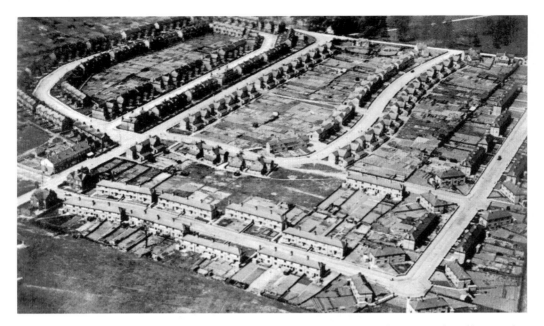

'It was not so very long ago since there were but 40 or 50 houses in the [Carcroft] village; today there something like 400 houses,' reported the *Don. Chron.* of 20 May 1910, adding: 'The builder is still busily engaged in the village, putting up a useful of tenement, such as lets readily to colliery employees.' At the time of the newspaper's visit, a number of land surveyors and their assistants were busily mapping out further developments and notice boards were prominently displayed in green fields, announcing 'eligible building plots for sale'.

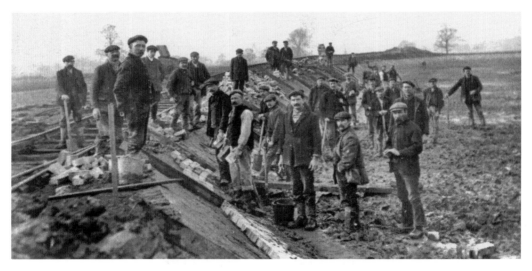

Laying the loop or spur line for Bullcroft Colliery. George Dow, in *Great Central Vol. 3* (1965), states that Bullcroft Colliery was attached by a branch, about two miles in length, to the Hull & Barnsley and Great Central Joint line extending between Aire Junction and Northern Junction (Braithwell): 'Construction was started by Logan & Hemingway early 1911 and the main line and all its branches were opened for goods and mineral traffic on 1 May 1916.' C. T. Goode, in *Railways in South Yorkshire* (1975), adds further intricate detail: 'Turning south westwards the [Joint] line ... [ran to] Bullcroft junction ... With 57 levers ... the box was the largest on the line and controlled a short double spur ... [including] a longer run of single track running west to Bullcroft Colliery ... No station was provided at Bullcroft junction, nor was any provision made for miners' specials.'

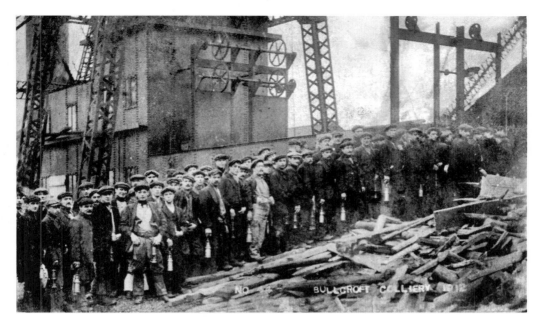

Miners at Bullcroft Colliery in 1912. 'The club movement has established itself prominently in the new district until at present there is a very flourishing institution for the miners,' the *Don. Chron.* said on 16 May 1913. The building occupied a central spot, being directly opposite the colliery gates. Three years earlier, about thirty-two men got together and launched the club in a barn. 'At the present time a scheme is on foot to erect a new club on modern ideas ... [to accommodate] the present 300 members. Under the proposed new scheme it is intended to spend £1,400 on the site and £1,800 on the new building,' added the newspaper.

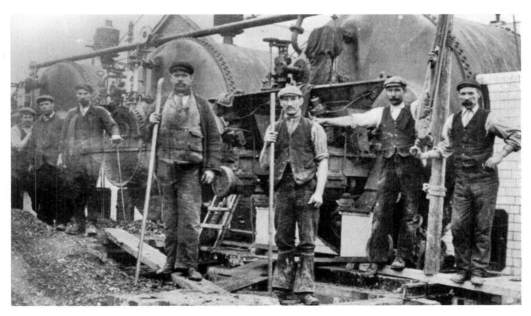

Men posing alongside boilers at Bullcroft Colliery. During the early 1920s, output at Bullcroft rose to nearly 30,000 tons of coal per week. The work force at this time was about 3,000 men. Later in the decade, the Bullcroft workforce of around 2,800 men was producing 1 million tons of coal annually. But during the 1930s, under the quota system imposed by the Mines Act (1930), Bullcroft mined 700,000 tons with a work force of about 2,600. During the 1950s, around 1,500 employees mined about 500,000 tons annually, but this gradually declined through the following decade.

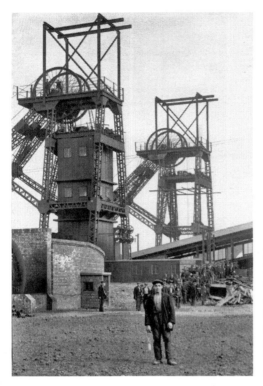

Bullcroft Colliery miner posing alongside No. 1 headgear on the left; note the square casing. Christine Heap, in *Mines and Miners of Doncaster* (1977), mentions: 'Diseases such as nystagmus of the eyes, caused by poor lighting, and silicosis of the lungs, caused by the dust in the mineworkings, have crippled thousands of Yorkshire miners. Deaths from falling roofs and runaway coal tubs were all too common.'

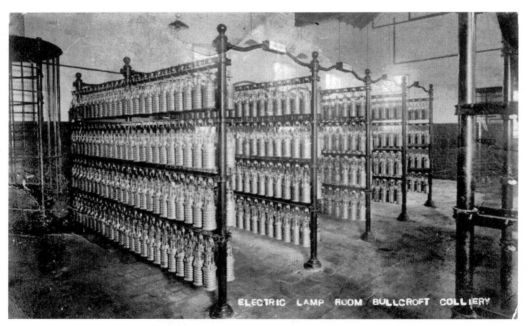

Interior view of Bullcroft Colliery lamp cabin, *c.* 1912, where lamps are being charged. On www.minerslamps.net, it is recorded: 'The safety lamp started to be replaced with electric mine lighting devices after 1900. By 1930 or so, almost all flame safety lamps were replaced by electric lamps ... The new wet cell electric lamps were not only safer but offered higher levels of luminosity than had been previously possible with flame safety lamps. By the 1940s the lighter electric cap lamp, with its waist-mounted battery pack, was fairly rapidly accepted in most mining areas.' However, the Flame Safety Lamp is still in use in all British coal mines and is a legal requirement for all mine officials.

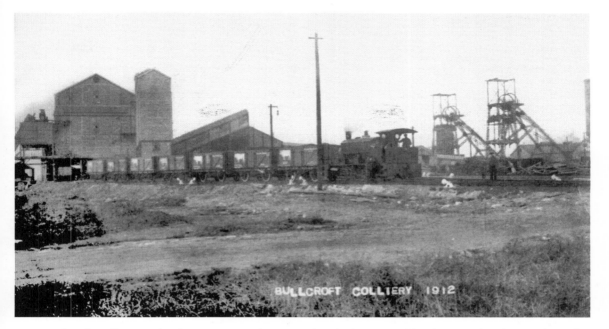

Bullcroft Colliery, with a locomotive working at right. The lattice steel headgear replaced ones of wooden construction, the use of the latter being banned under the Mines Act of 1911. The steel headgear was manufactured by Markham & Co. of Chesterfield. The original small chimney is just visible on the right and was later replace by one much taller. On the left is the German-built coal washery and screening plant.

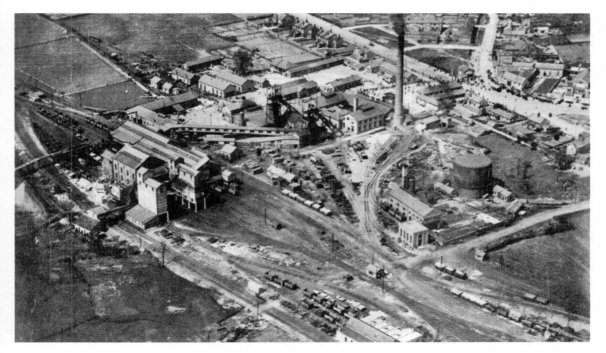

An aerial view of the Bullcroft Colliery site, looking north-west, c. 1926. Progress may be seen with regard to house building in the top right quarter of the picture; the Wesley chapel and new cinema are also visible. 'It is the largest picture house not only in the district but even in Doncaster, having seating capacity for a thousand and a splendid stage which may be used for concerts, meetings and the like. Indeed, as a public hall, it is a great asset ...' reported the *Don. Chron.* on 16 May 1913.

From 1921 until the start of the Second World War, Heap (*op. cit.*) details the sharp drop in the demand for coal and the experience by most Yorkshire miners of periods of unemployment and short-time working: 'Matters came to a head in 1926 when the Coalowners, alarmed at falling profits, offered less wages for a longer working week. The miners coined the phrase "Not a penny off the pay, not a minute on the day", and were locked out. [The General Strike followed and then the miners fought on alone] until the Winter when they had to give in to the Coalowners and accept their terms.' Miners Bernard Hutchinson and Albert Middleton are pictured at Bullcroft Colliery.

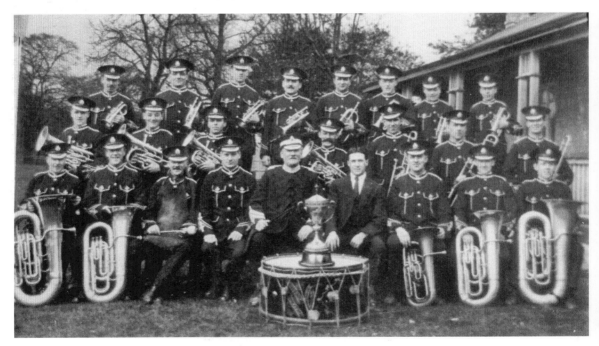

The brass band at Bullcroft (in existence from *c.* 1927 to *c.* 1970, but now extinct) has been noted as the Bullcroft Colliery Ambulance Band, Bullcroft Miners' Ambulance Band and Bullcroft Miners Ambulance Band. Conductors have included James Woods, Jack Boddice and Albert Chappell. On the website www.worksopminerswelfareband.org.uk, general details of the association of brass bands with the mining industry are given: 'Most Colliery Bands were supported by the mine owners and later by the Coal Industry Social Welfare Organisation (CISWO) and the former National Coal Board. It is said that in the early years the mine owners bestowed patronage on their bandsmen in giving them comparatively light or surface duties. Others who did not wish to encourage a band did precisely the opposite!'

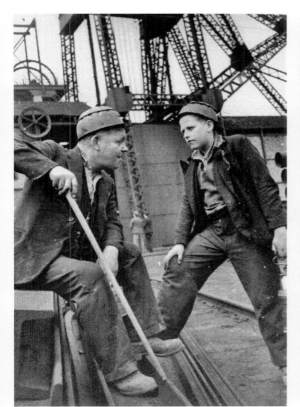 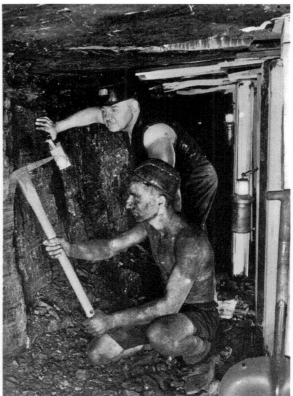

Above, left and right: Looking at the web reference '*BULLCROFT COLLIERY, DONCASTER (ACCIDENT)*' (*Hansard*, 2 February 1937), some startling facts emerge. After working only six days at Bullcroft Colliery, Kenneth Oliver, aged fourteen, was killed on 13 January 1937 while engaged in uncoupling tubs. Although he was working under the supervision of an adult haulage hand and was required to uncouple tubs only when the set was standing, such work, it was argued, was not suitable for an inexperienced boy. The Coal Mines General Regulations did not prescribe any course of training for boys entering the industry. In the House, Alfred Short, MP for Doncaster from 1935 to 1938, asked if the question 'of accidents to children of these tender years [would] come before the Commission that is now dealing with safety in mines, and may we expect a recommendation from it upon this matter?' Captain Harry Crookshank (Conservative) replied: 'The evidence which has been put before the Commission has very forcibly brought to its notice the whole question of the safety of boys in the mining industry.' The picture on the left shows a young boy and older collier at Bullcroft; the one on the right shows a scene at the coalface.

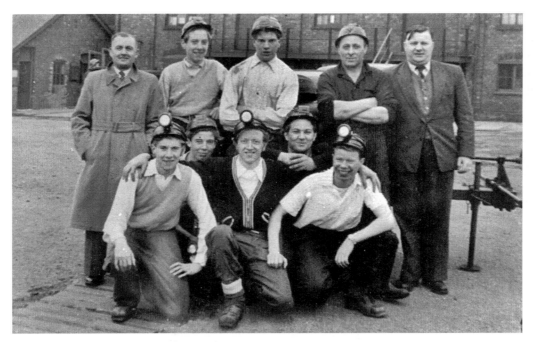

Above and below: Pithead baths were opened at Bullcroft Colliery in September 1951, at a cost of over £80,000. Attached to them, and opened at the same time, was a medical centre, comprising doctor's room, nurse's room, bathroom and waiting room, which cost £9,000, and a cycle park for 300 bikes at £1,000. They were opened by Joe Hall, president of the Yorkshire area of the NUM. A Coal Board official said: 'It is the aim of the Coal Board that every miner in every pit should be able to go home clean.' Tom Cowan, secretary of the Bullcroft branch of the NUM, said: 'This is the greatest moment in the history of this colliery. We have been waiting for these baths a very long time. When the lads can come and get cleaned up before they go home, they will be happier than they have been for a long time.' People identified in the top picture include Mr Bedford, Fred Camm, J. Huby, ? Belshaw, George West, Bill Brackenbury, Stan Thompson. In the bottom picture, K. Owen, P. Hancock, D. Chantry, F. Ward, R. Fails, E. England, F. Adams, J. Huby, G. Bedford, D. Slight, ? Alsopp.

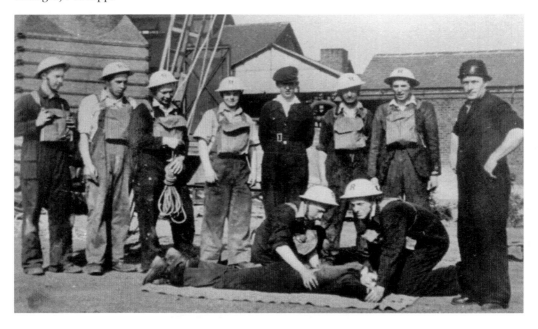

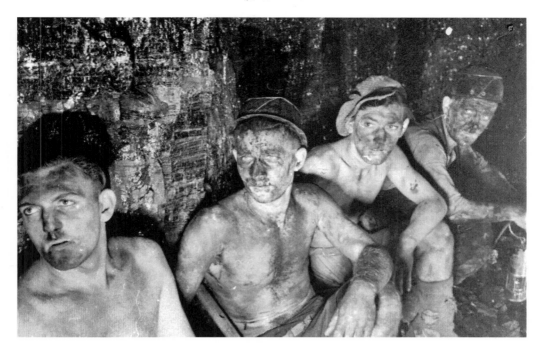

Above and below: About 300 men were thrown idle at Bullcroft Main Colliery on the afternoon shift on Wednesday 19 March 1952, because the haulage hands refused to work with Italians on similar duties. Nearly 100 men who had gone below to begin the shift had to be withdrawn. Others were stopped when about to step on to the cage at the pithead. Bullcroft, with about thirty Italians employed in a full complement of about 1,600, had a larger proportion than the majority of pits. One reason appeared to be that most of the Italians were engaged on haulage and because they were adults, they were entitled to the pay of adults. But most of the English haulage hands were under twenty-one, and so were not entitled to the same rate of pay. The English boys protested that the Italians were receiving more in wages than they were. Tom Cowan, secretary of the Bullcroft branch of the NUM, said the branch officials had made strong appeals to the haulage hands to return to work, but they had been determined not to do so. Later it was agreed that the Italians should be temporarily suspended and there should be a full return to work of the others.

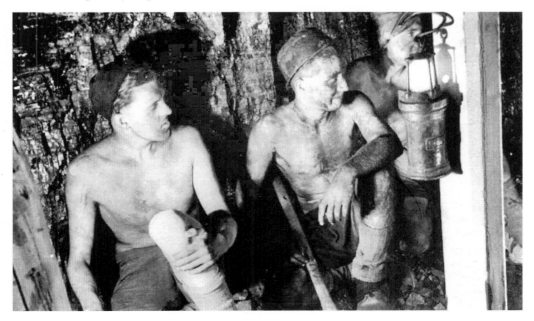

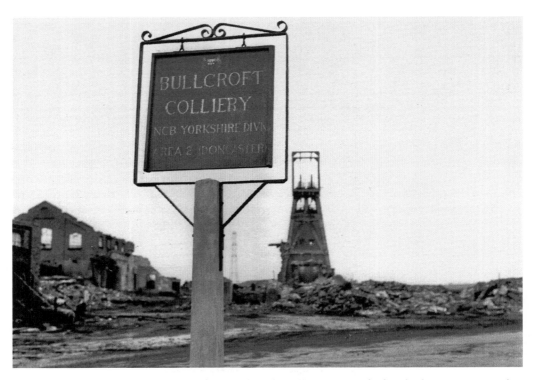

Above and below: Miners emerged from Bullcroft Colliery, Carcroft, for the last time on Friday 25 September 1970. On the Monday of the following week, the 700 men from 'Bully' were to make their way to Brodsworth Colliery, just a mile away. Only forty would be made redundant, all over the age of sixty. Left behind were a few salvage men. The merger was to mean the closure of two of the three Bullcroft faces. The third face would still be worked out, but all the men were to go down the Brodsworth shaft to reach the coalface under both pits. Underground conditions at Bullcroft – including water trouble at the Dunsil face – had allegedly contributed to an earlier than scheduled closure. Two teams of tunnellers had joined the two pits in June of 1970 with a huge quarter-mile underground link. The shafts at Bullcroft were filled using spoil from pit heaps and capped. Bullcroft Colliery kept its Landsale depot to deal with concessionary coal and retained a locomotive to work it for about a year afterwards. Until 1985, the NCB used part of the site for its workshops. Currently the area is titled Carcroft Enterprise Park, providing a diverse range of units with varying eaves heights and office facilities.

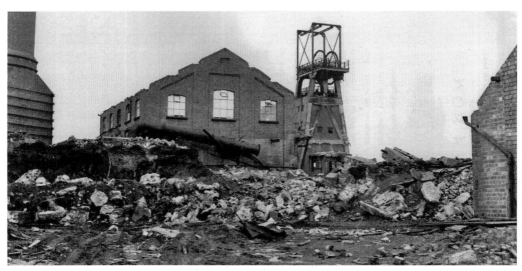

Cadeby Colliery

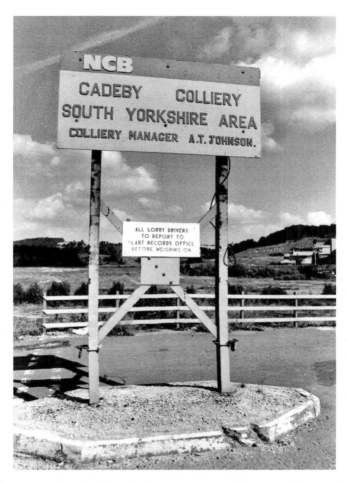

'It was not until 189[3], when the Denaby Company opened its new colliery at Cadeby that the digging of coal from the concealed coalfield really began,' stated Heap (*op. cit.*). Cadeby colliery reached the thick and profitable Barnsley seam at a depth of 2,250 feet. The seam extended deep under and right across the Doncaster district, and actually outcrops near Barnsley. Due to a fault known as the Great Don fault, extending between Denaby and Cadeby Collieries, the Barnsley seam was at a greater depth at Cadeby. After sinkers overcame considerable problems with loose boulder clay water pouring out of fissured sandstone, the Barnsley seam was reached at Cadeby on 29 July 1893. The headgear measured 89 feet 6 inches in height and a chimney discharging smoke and steam 180 feet. Initially, workmen on the site were ferried across the River Don in a small boat. By June 1892 a bridge was constructed, giving access to the colliery. The Cadeby Colliery sign was photographed on 11 September 1986.

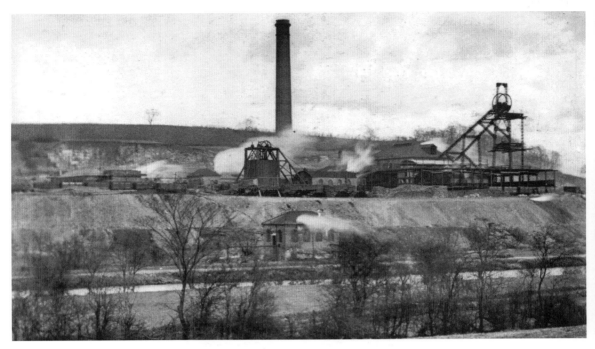

Above and below: A contingent from the American Institute of Mining Engineers arrived in Yorkshire from London on Monday 30 July 1906. The party, who were guests of the Iron and Steel Institute for an interchange of ideas and methods in mining and iron and steel working, were to inspect the principal mines and ironworks in the country. Nine of the party of about 120, which included wives and daughters, visited Cadeby Colliery. They were met at Conisbrough station by the managing director of Denaby & Cadeby Main Collieries, W. H. Chambers. The majority of the party descended No. 2 shaft, which was 750 yards deep. They penetrated the workings of the Barnsley seam to a distance of about 1,600 yards, where men, stripped to the waist, were 'perspiringly hacking away at the face of the coal'. The thickness of the seam varied from 9 to 12 feet. Both pictures show shaft No. 1 on the right and No. 2 on the left. Sandwiched between them is the powerhouse.

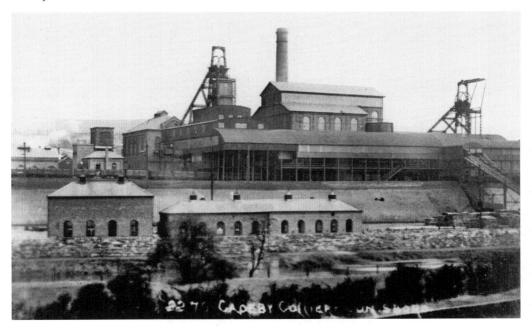

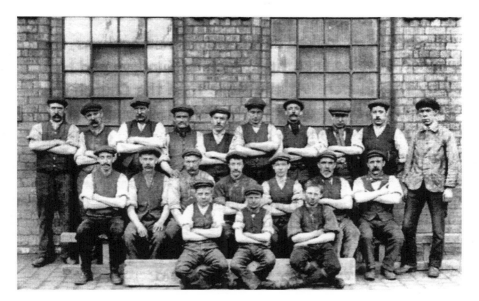

Formal group of workers at Cadeby. The Denaby Main Colliery Company erected several hundred new houses in Denaby for the miners at Cadeby Colliery during the early 1890s. J. McFarlane, in *The Bag Muck Strike Denaby Main 1902–1903* (1987), gives further details: 'Although some of the men who were employed at the two collieries lived in privately owned accommodation at Mexborough and Conisbrough, the majority were housed in the 1,000 company-owned cottages within the village of Denaby Main itself. These colliery-owned houses were an important instrument of social control ...'

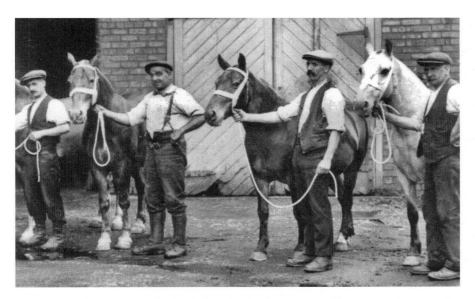

At one time, horses drew the loaded coal tubs from the coalface to a point near the pit bottom. Ropes were then attached to the tubs to haul them the remainder of the journey. A. J. Booth, in the *Railway History of Denaby & Cadeby Collieries*, 1990, states: 'Being a vital part of the operation, [the ponies] were very well looked after, and a Colliery company employee known as the 'Head Horseman' ordered their food ... the hostler also organised the vet when required ... On each shift there was one man underground who looked after the horses.'

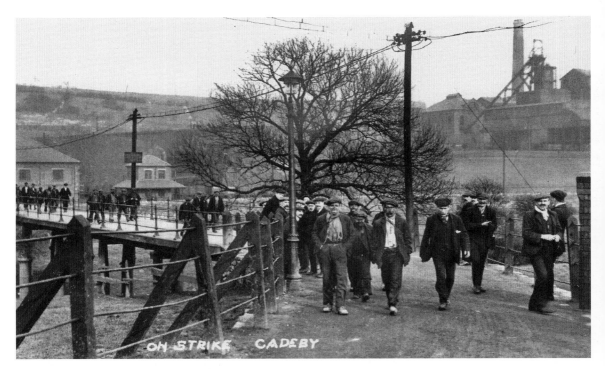

Above and below: A national coal strike, beginning on 1 March 1912 and involving around a million men in the industry, aimed to win a minimum wage for each coal mining district. In the Yorkshire coalfield, no coal was drawn anywhere after four o'clock on Thursday afternoon. The Cadeby Colliery men, some of whom are seen here, ceased work at the end of Wednesday morning's shift. After forty days and a national ballot, the miners returned to work. This latter was precipitated by the passing of the Coal Mines (Minimum Wages) Act, 1912. This stipulated that in future, minimum wages were to be negotiated by local boards on each mining district. Each board was to have a neutral chairman. Returning to Cadeby Colliery, miners found it in a bad condition and coal was not drawn there for about a week.

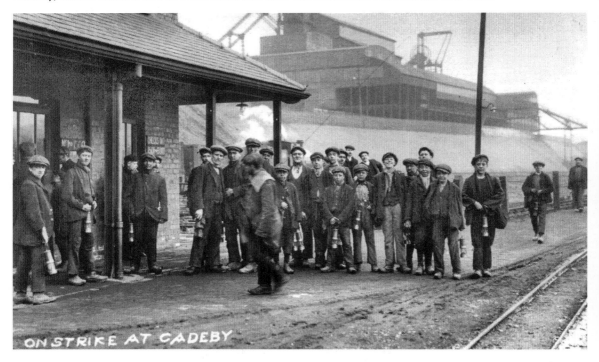

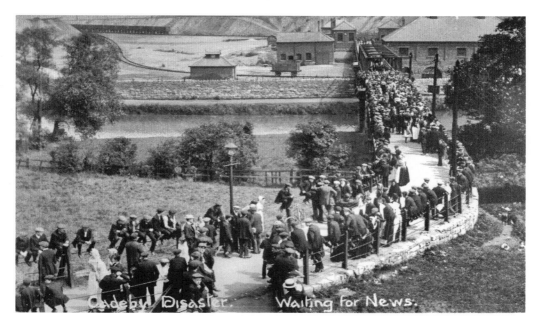

Above and below: Early on the morning of Tuesday 9 July 1912, there was a huge explosion in the south district of Cadeby Colliery. Out of the thirty-seven men who were working in the south district, thirty-five lost their lives. The two men who survived the explosion were Albert Wildman and William Humphries. The Denaby and Cadeby Rescue Team were down the colliery within half an hour, while within the same time span the Wath Rescue Station had sent over a motorcar full of men. Accompanying the Wath team was Sgt-Instructor Winch, and he marshalled the rescue operations. It was about 6 a.m. before work could begin on recovering the bodies. Three hours later, the dead were carried out of the pit and down the long gantries in full view of the alarmed onlookers. Later, the crowds were to swell to an estimated 80,000. At 11.30 a.m. a second disaster occurred when an explosion engulfed the rescuers who were taking the bodies away. The death toll leapt from thirty-five to seventy-five. Those who perished included three government inspectors. The second explosion brought down a very large roof fall, estimated to be around 200 tons.

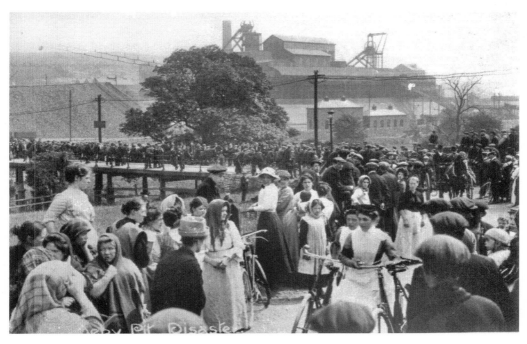

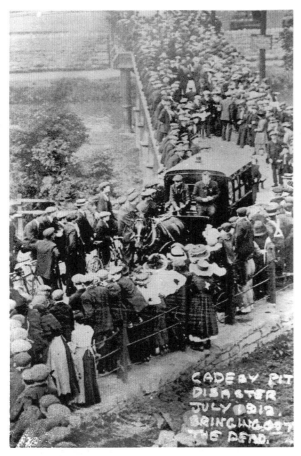

Left and below: A number of rescuers were caught in the huge fall, while others were cut off by it and gassed. The dead included the government inspectors W. H. Pickering, G. Tickle, H. R. Hewitt, D. Chambers and H. Cusworth. W. H. Pickering was looked upon as one of the leading authorities on coal mining in the world. Sgt Winch and a man named Lawrence of the Denaby Rescue Party were the only survivors of the Denaby and Cadeby Rescue Teams, the remainder being wiped out. Messages of sympathy were posted on railings outside the colliery's general office. There were messages from the King and Queen and the Home Secretary. That night, at around 3.30 a.m., the rescue workers, attempting to shut off the deadly south district by brick stoppings in the in-take and return airways, narrowly escaped another catastrophe when a third explosion blew out the stoppings and they had to scurry for their lives. Two men sustained serious injury.

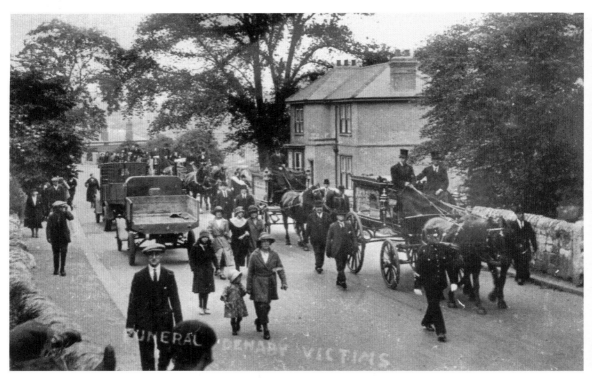

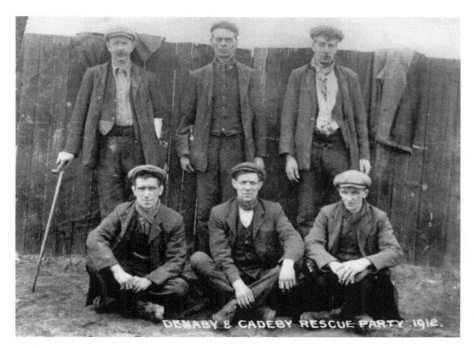

Above and below: At about 7.30, the King and Queen arrived. They had motored over from Wentworth with Earl Fitzwilliam and Lord Stanfordham. They were received in the colliery offices by W. H. Chambers and J. R. R. Wilson, who supplied them with particulars of the disaster. Frank Allen got his jury together, and with them viewed the bodies. After several identifications were brought forward, Allen went across to the colliery offices to sign the necessary death certificates permitting the removal of the bodies, though none were removed on Tuesday night. Next morning there were distinguished visitors to the village, including the Viscount and Viscountess Halifax, E. Buckingham Pope, the chairman of the Denaby & Cadeby Collieries, and the Archbishop of York. When the Archbishop left the colliery yard, he made a tour of Denaby and Conisbrough, visiting the homes of several of the mourning families. As the King and Queen had been the one bright spot of Tuesday, the Archbishop's visit was the only alleviating feature of the gloom and despair of Wednesday. All that could be seen up and down the streets in the area were drawn blinds and women discussing the incident.

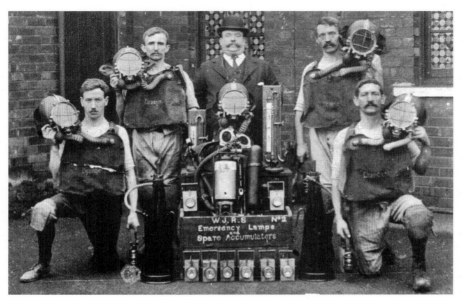

This picture was reproduced in the *South Yorkshire Times* of Friday 29 January 1926. Beneath it was the caption: 'A delegation of miners' representatives at Ferry Farm, Conisbrough, last Saturday. Ferry Farm has been acquired by the Denaby and Cadeby Miners' Home Coal Carting Company, for the accommodation of their horses and vehicles. In the above group, a little to the right of the centre is Mr Herbert Smith, president of the Miners' Federation and the Yorkshire Miners' Association (in his characteristic cloth cap), and on his right is Mr J. Hall, financial secretary to the Yorkshire Miners' Association; on his left, Mr T. Williams, M.P.'

Conisbrough and Denaby miners queuing for food at a soup kitchen on Lesley Avenue, Conisbrough, during the 1926 General Strike. The man on the left, Benjamin Roberts Snr, was a prominent local miners' union official for many years. Note the condition of the men's clothing. During the 1926 Strike, the Conisbrough and Denaby Distress Fund provided meals twice a week from eight centres. About 8,000 dinners were provided each week. 'The effect [of the 1926 General Strike] on the British coal mining industry was profound. By the late 1930s, employment in mining had fallen by more than one-third from its pre-strike peak of 1.2 million miners, but productivity had rebounded from under 200 tons produced per miner to over 300 tons by the outbreak of the Second World War,' noted Peter Mathias in *The First Industrial Nation* (2001).

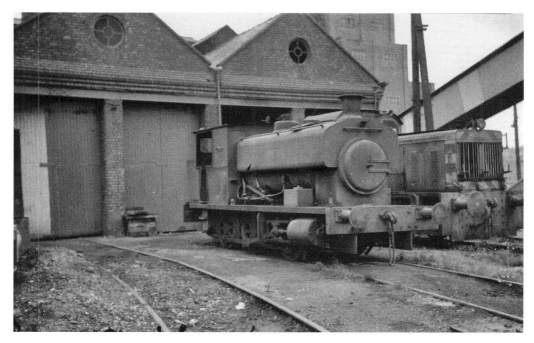

Above and below: The top picture, taken *c.* 1971, shows 0-6-0ST locomotive no. 25 standing in the loco shed yard. The locomotive arrived at the colliery in 1962 and was scrapped on site eleven years later. The bottom illustration shows three internal standard gauge locomotives outside the Cadeby Main locomotive shed, which contained six roads, on 22 April 1987. Cadeby Main took delivery of their first two diesels in 1958/59 and Booth (*op. cit.*) informs us: 'The first diesel ('Dick') came from Hudswell Clarke's of Leeds (works no. D115), ex works on 28 November 1958. It was a standard gauge 0-6-0 diesel mechanical and cost £14,374.' The locomotives are from left to right: *Dick*, no. 55; *David*, no. 58; and *Ken*, no. 67. *Ken*, costing £17,000 and built by the firm Sentinel (Shrewsbury), arrived at Cadeby on 27 February 1964. When Cadeby was being run down prior to closure, it transferred to Maltby Colliery (8 May 1987). From there it passed into preservation with the South Yorkshire Railway at Meadowhall, but is currently with the Andrew Briddon Locomotive Collection.

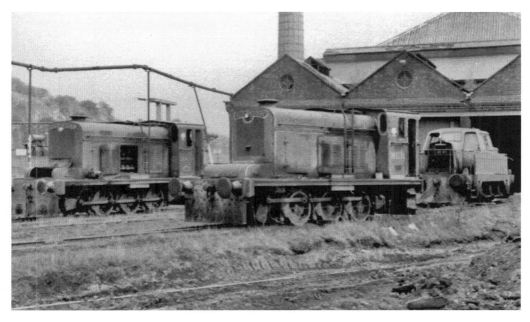

Cadeby Colliery Coal Queen Jackie Barnard pictured on 20 April 1982.

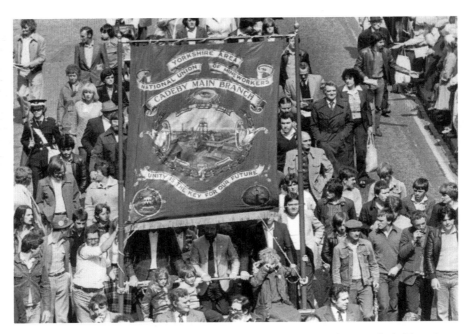

Cadeby Colliery miners at the Yorkshire Miners' Demonstration Gala at Wakefield 21 June 1980. In the top right of the picture DMBC Councillor and author Jim McFarlane may be identified. The Cadeby Colliery banner, strongly featuring the colours of royal blue and gold, has a painting of Cadeby Colliery in the centre with a motto beneath it stating: 'Unity is the key for our future.' Above the painting of Cadeby Colliery is the All Seeing Eye, which allegedly symbolises the Union's protection of the workers and the shift away from the privately owned coal mines to the union-led mines, pioneering progression and safety. On one of the emblems at the bottom is the Latin motto for Cadeby, 'Out of darkness, light.' The banner is housed in the Denaby & Cadeby Miners' Welfare Club at Denaby.

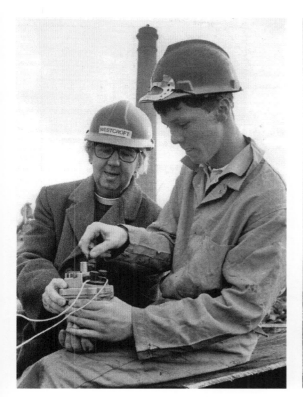
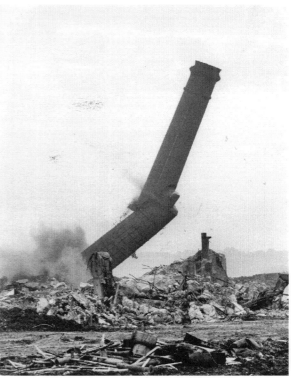

Above, left and right: Early in March 1986, news was announced that the NCB was to axe another pit, Cadeby Colliery. The pit, which five years earlier had employed 1,200 men, was expected to make a loss of £3.4 million for the financial year. Harold Taylor, NCB South Yorkshire Area Director, guaranteed jobs for the 321 staff if they wanted to remain in the mining industry. More than 7,800 South Yorkshire miners had accepted redundancy over the previous year. On 24 December 1986, those men who decided to take redundancy left Cadeby. Only a skeleton workforce returned after the Christmas break to complete filling in of shafts and assist demolition. In October 1987, fifteen-year-old Lee Johnson was given the chance to press the demolition button at Cadeby when his mother Shirley won a raffle to do so and passed the prize on to him. The raffle to press the button was organised as part of a £20,000 scheme to raise money for a miners' memorial chapel at the Denaby parish church of All Saints. Lee is pictured with Reg Davies, vicar of Denaby.

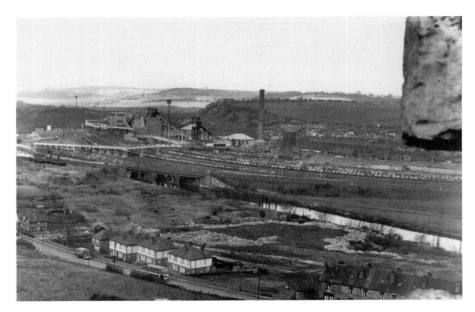

Above and below: Following clearance of the Cadeby Colliery site, work began on the initial stages of the Earth Centre, which was intended to 'establish a world centre for sustainable development promoting the best environmental and sustainable practice'. The first plans incorporated community-led projects, with much construction work being undertaken by Mowlem, who used the site to train apprentices. The first stage of that project opened in 1994, including an aquaculture centre and a community farm. A year later the Millennium Commission awarded £41.6 million to the Earth Centre, which became one of its Landmark Millennium projects. From 1996, work progressed on the remediation of the remaining land and the design and construction of the many buildings and exhibitions. Phase 2 of the Earth Centre opened in May 2001 with more attractions as money from grants and other sources became available. A pirate ship was built, a crazy golf course and indoor 'Amazon Adventure' play area. But by 2003 the target visitor numbers were not being met, and by 2004 it was evident that the centre was unviable. In September 2004 the attraction closed to the public, and by the end of October the Earth Centre was put in the hands of administrators. In February 2010, it was revealed that Doncaster Council was spending £200,000 a year to maintain the site. The centre was put up for sale in October 2010 and, on 23 March 2011, was sold for an undisclosed sum.

Denaby Main Colliery

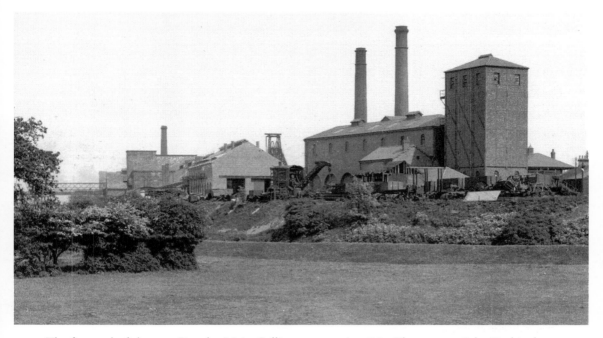

The first sod of the new Denaby Main Colliery was cut in 1863. The owners, John Buskingham Pope, a London coal factor, and George Pearson, a railway contractor, leased the land from Thrybergh Hall's Fullerton family. Interestingly, coal had been mined as a surface outcrop at Denaby in medieval times, and in 1847 there was a reference to a close there called Coletypes. After overcoming considerable problems with water, the Barnsley seam was reached 449 yards below ground. It was the deepest seam in Yorkshire and well over nine feet thick. The colliery, and other service industries which sprang up, drew a large variety of workers to the area. The colliery was also well sited, adjacent to the Sheffield & Lincolnshire Railway and the River Don. During the 1870s Denaby's population reached 695, an increase of 492 on the figure for 1861. At this period there were around 100 colliery-built houses. A proportion of the colliery housing was built at forty-nine to the acre, and in some instances ten people were living in a four-roomed house. None of the houses had bathrooms, water closets or hot or cold running water. Night soil men emptied the earth closets and middens weekly.

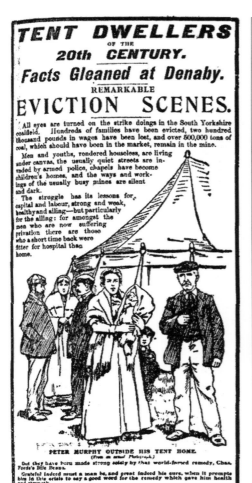

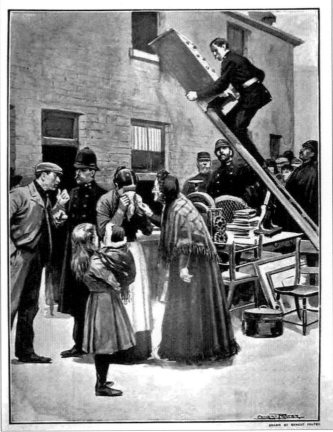

Above, left and right: At the beginning of the last century the combined workforce of Denaby and Cadeby collieries totalled some 4,000 men, and many lived in the company's houses. During 1869 and 1885, when there had been industrial disputes, miners and their families had been evicted from their homes, but in 1902–3, when the 'Bag Muck Strike' occurred, evictions brought enormous publicity to the area. According to Jim McFarlane in *The Bag Muck Strike, Denaby Main 1902–1903* (1987), the cause of the strike was 'over the payment for removing "bag muck" – an uneven layer of rock running through the Barnsley bed seam of coal'. The strike began at the end of June 1902 and it was not until 26 July that miners and their families received their first strike pay, having previously existed on money from items they had pawned and donations. The strike pay amounted to 9s per man and 1s per child per week. It was not enough, however, and the Conisbrough School Board reported: 'Many of the children attending public day schools are insufficiently fed.' Other bodies like the Salvation Army and Baptist Mission Fund provided some help.

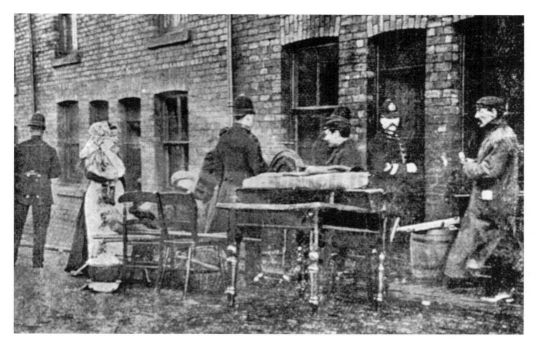

Above and below: The *Mexborough & Swinton Times* of 8 August 1902 reported: 'This week, 8,000 loaves of bread have been distributed – this is 1,000 more than last week.' The cost of the bread was defrayed from subscriptions collected by the men, and from grants made by the workmen of other collieries. By Christmas the strike was twenty-six weeks old and some of the families had fled the villages. There was no coal for heating and cooking, and food was expensive. Then the colliery company was granted eviction orders against 750 of its tenants. On 6 January 1903, Supt Blake of Doncaster went to Denaby, along with 200 of his men, to begin the evictions. Some of the police were armed with cutlasses and they met with little opposition from the Denaby residents. The police did not welcome their task and a journalist for the *Mexborough & Swinton Times* of 9 January 1903 wrote: 'I saw some constables who, in one case, did everything but shed tears. That was in the case of Edlington Street, where the family goods had been removed into the street ...'

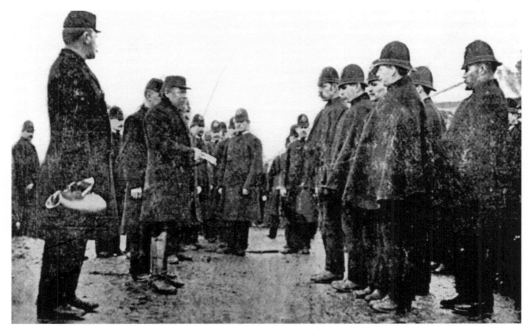

By Friday 9 January 1903, the evictions were complete. Snow fell and people were housed in chapels, school rooms and tents. On 5 and 6 February, the colliery company announced the reopening of the pits and advertised for labour, some of which came from other areas. On 22 March 1903, most of the men returned to work, dejected and betrayed. But as one miner put it: 'Better to have strived and lost than not to have strived at all.'

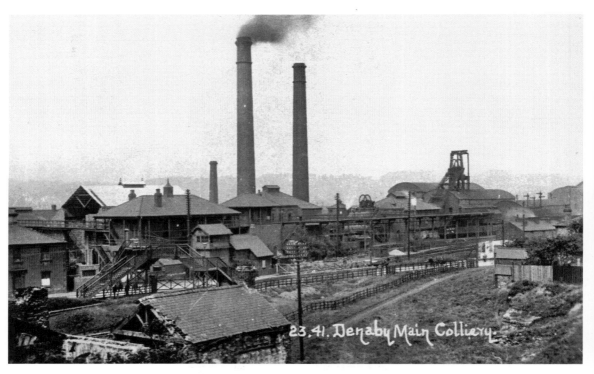

View looking north-east at Denaby Main Colliery; the level crossing is in the bottom left of the picture. The upcast and downcast shafts were 40 yards apart; the downcast shaft raised coal tubs, while the upcast was mainly used for manriding. The buildings at surface level included an engine house, fitting shop, washer, screen house, fan house, lamp room and coke ovens. When the Denaby Main Colliery Company opened the Cadeby Colliery in 1893, the company name was changed to the Denaby & Cadeby Main Collieries Ltd.

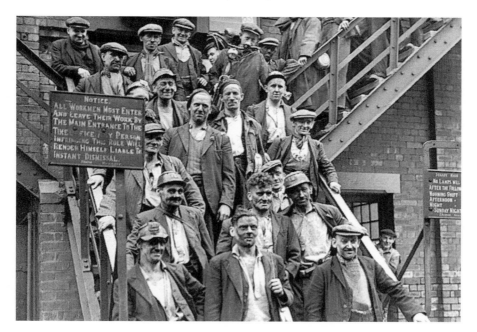

Denaby Main Colliery miners pictured in the late 1940s after finishing a shift. Manning levels at Denaby in 1946 were recorded as 1,450 underground and 400 on the surface. Earlier, in 1938, the highest manning levels in the history of the colliery were recorded: 2,000 underground and 500 on the surface.

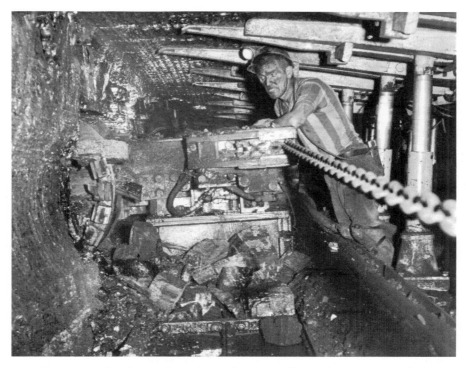

Taken on 1 June 1966, the picture shows a 150-hp trepan-shearer in use at 6's and 7's unit in the Haigh Moor seam at Denaby Main Colliery. The roof is supported by Dobson five-leg powered supports and the coal leaves the face on a 30-inch-wide armoured face conveyor. This face was one of the longest in the county at 365 yards, and was the first in Yorkshire to have Dobson five-leg supports.

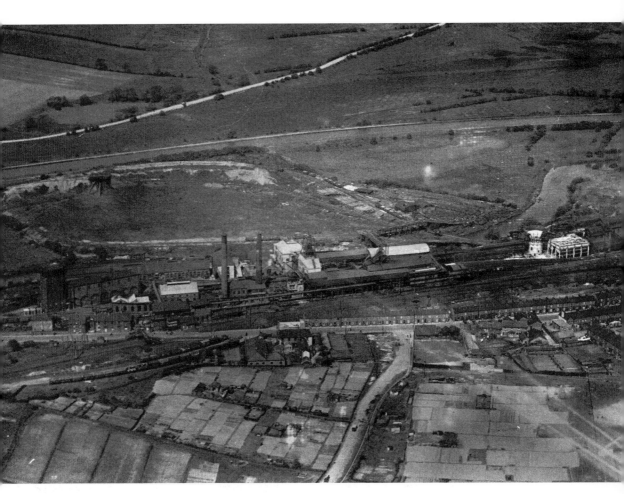

Aerial view of Denaby Main Colliery looking north, with Doncaster Road cutting through the lower regions of the picture. The Reresby Arms public house and level crossing are off centre to the left. Under the heading 'The Denaby – Cadeby Link Up' the *South Yorkshire Times* of 7 June 1958 informed: 'The National Coal Board's centralisation scheme for Denaby and Cadeby Collieries is now nearing completion ... The 4¼ million [pounds] scheme includes the underground link between the two pits, which was completed some time ago; the laying of new railway sidings, also completed; the erection of a new giant coal preparation plant, now nearing completion, and the installation of electrical winding gear at Cadeby, also completed ... Since the scheme started many workers had been employed in the alterations needed for the link-up and when it was completed many of these would be transferred back to coal-face working ...'

Right and below: The colliery came to the official end after the night shift on Friday 31 May 1968. From that point its merger with its neighbour, Cadeby Colliery, was complete and no more men would ride the Denaby shaft. Three hundred men would continue to work the face of South West 3 at Denaby after the Whitsuntide holiday, but they were to work it from Cadeby. A year earlier, the Denaby pit had 1,500 men. Hundreds had been transferred to Cadeby and more than 120 made redundant in the merger. The first of these men, all aged sixty or over, collected their redundancy cheques that Friday afternoon. One, George Walker, aged sixty, of Braithwell Street, Denaby Main, told the *Doncaster Evening Post* of 1 June 1968: 'A man with 46 years in the pit – he's had enough.' George Burton, sixty-three, of Warmsworth Street, Denaby, said: 'It seems hard to realise that Denaby really is closing. It has always been there and men have always seemed to be on their way to work or on their way home. I don't think I'll fully realise it until the place stands deserted. Mechanisation has taken a lot of the blood and sweat out of coal getting. In my time it was hand-cut coal and hard graft all the way.' The bottom picture, taken by Geoff Warnes, shows a Beyer-Peacock 0-6-0ST at Denaby Colliery on 18 February 1961.

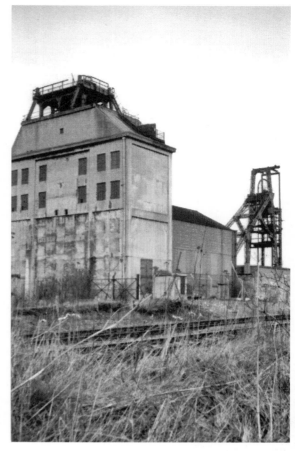

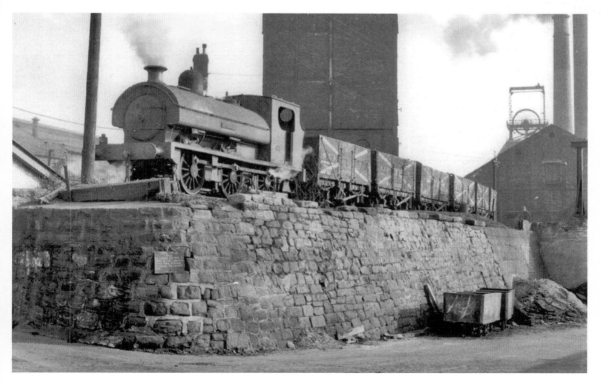

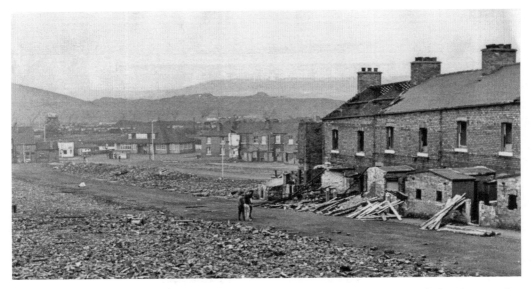

Above and below: Jim McFarlane, in his article 'Denaby Main Colliery', stated that the Barnsley seam was worked at Denaby up to the very end and worked with pick and shovel, 'hand got into tubs. No conveyor belt, coal cutting machine or shot firing was employed in the coal getting process ... Two additional seams were also being worked on more modern mining methods – the "Parkgate" or "Deep" and the "High Moor" seams. The reason for the Denaby closure was said to be because of the amalgamation of the pit with Cadeby Main Colliery – some colliers say "they closed the wrong pit".'

During its lifespan, Denaby Main Colliery mined approximately 50 million tons of coal. According to the Annual Reports of the Inspector of Mines, 203 miners lost their lives at the colliery. Shortly after the closure of Denaby Colliery, the rebuilding of the village took place. All the terraced houses were demolished and replaced with modern semi-detached properties on an open-plan scheme. In 1987, the Miners' Memorial Chapel in All Saints' church, Denaby, opened, serving as a memorial to all those who had worked in the collieries of the area. It contains a pit wheel, salvaged from Cadeby Colliery. Both photographs were taken on 19 November 1975.

Doncaster Coal Board Offices and Rescue Station

The drawing for the National Coal Board's Divisional Headquarters in Doncaster. The building was known as Coal House and was designed by J. G. Poulson, architect and town planner, of Pontefract, London, Middlesbrough and Edinburgh. The National Coal Board (NCB) was the statutory corporation created to run the nationalised coal mining industry. Set up under the Coal Industry Nationalisation Act 1946, it took over the mines on 'vesting day', 1 January 1947. The number of companies taken over by the Board was about 200, at a cost of £338 million. In 1987 it was renamed the British Coal Corporation, and its assets were subsequently privatised.

Construction of Coal House under way on 14 April 1965.

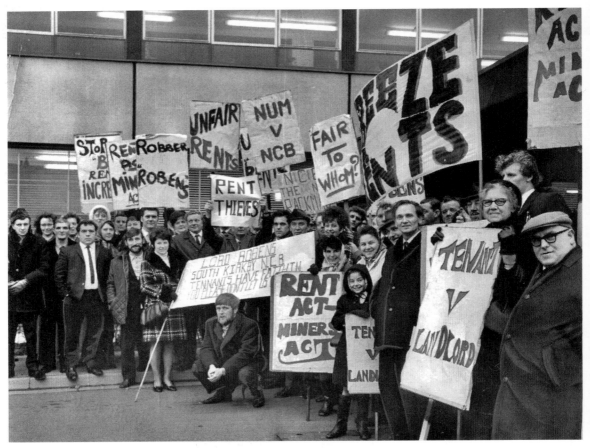

A protest outside the Doncaster Coal Board Offices by the NCB Tenants Association on 22 January 1970.

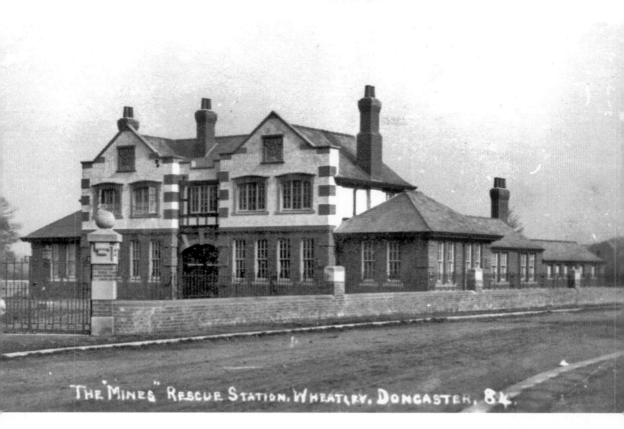

In November 1913, a Miners' Aid and Rescue Station at the corner of Wheatley Lane was nearing completion. It was within easy call of the various collieries in the Doncaster district. From the windows of the second floor the chimney stack of Bentley Colliery could be seen, and from the roof the smoke from Brodsworth and Bullcroft was discernable. The *Don. Chron.* of Friday 28 November noted: 'When the sinking of the Hatfield and Cantley pits is completed, the station will be in the centre of a belt of collieries and should prove of the utmost service in the case of serious pit accidents. It is proposed to train three teams of men, and there is an observation hall, 55 feet by 26 feet, which will permit observation to be made of experiments in the fume gallery which adjoins it. The architecture of the building is pleasing to the eye, and one is struck by the large number of windows which will ensure the teams have plenty of light in which to carry out their experiments ... the best of work has been put into the building and expert workmen have been engaged to do special work. The floors in the corridors have been made by Italian workmen who employ a secret process which, while making the floors non-sound conducting, leaves a good hard surface ... Altogether it is estimated the structure ... will have cost about £9,000 and the greatest interest has been manifested in the work by the managers of the various collieries. We understand that an instructor has been appointed for the instruction of the teams.' On 28 December 1990, the *Don. Star* said that Doncaster Mines Rescue Station brigadesmen Dave Mee, thirty-six, and Gary Williams received the silver life-saving medal for assisting at two separate incidents in the previous year.

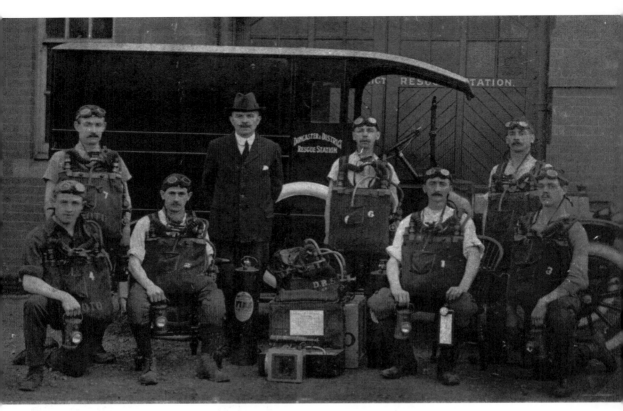

Before the opening of Britain's first mines rescue station at Tankersley in Yorkshire in 1902, pit managers and volunteers were the first untrained mines rescuers. They fought fires, rescued victims and recovered bodies in the mines in which they worked. Rescue stations were recommended by a Royal Commission in 1886, but were not compulsory, for the first time in history, until after the 1911 Coal Mines Act, albeit with a limited radius of action of 15 miles. In 1913, general regulations were made under the Act specifying how Rescue Stations should be managed, equipped and operated. There was also a deadline date in 1915 by which all collieries in the country had to be covered. By 1915 there were forty-six rescue stations, covering all the coal mining regions in the country. Every Central Mines Rescue Station was required by law to be under the control of a superintendent who had been trained in mines rescue work and had at least five years of underground experience, including a minimum of two years at the coalface, prior to his appointment. He was responsible for the day-to-day running of the station and the supervision of the instructors and other officials. The Mines Rescue Service has always given assistance to the civil and military authorities when requested and there are numerous cases on record where trained men helped to rescue persons, sometimes children, who were trapped or lost in old mine workings, shafts, potholes, caves, and in buildings following fires or accidents from other causes. Following the disaster at the Nypro Works at Flixborough, when twenty-eight men were killed, rescue workers from Doncaster rescue station and two local pits played a large part in the recovery of the bodies in most difficult and unpleasant circumstances.

Edlington: Yorkshire Main Colliery

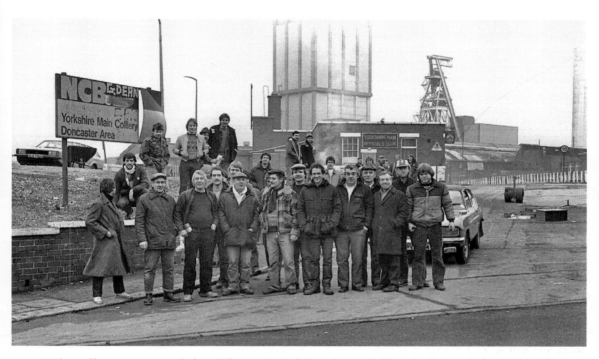

Pickersgill (*op. cit.*) stated that Edlington's Yorkshire Main Colliery had two shafts, each with a finished diameter of 21 feet 6 inches but widened out in the middle, which were sunk to the Barnsley Bed, which was reached at a depth of 907 yards. 'The thickness of the seam ... is 5' 6" to 6' with bag coal roof and clunch floor. It is wound from a greater depth than any other colliery in Yorkshire,' he wrote. The sinking was commenced in December 1909 and completed in July 1911. It began in the Magnesian Limestone of the Permian formation and entered the carboniferous measures at a depth of 74 yards. At this point, which is also the base of the Magnesian Limestone, the maximum feeder of water was encountered. It was 300 gallons per minutes. There was also a feeder of 60 gallons a minute 30 yards lower down. Pump lodges were made at these points during sinking, but the feeders diminished.

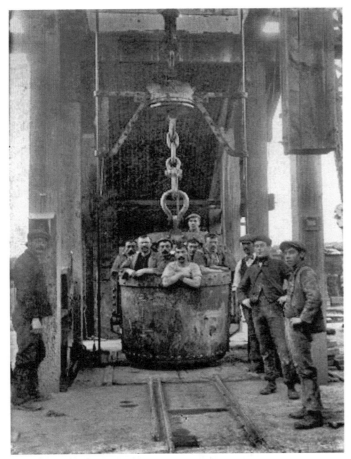

Left and below: Pickersgill (*op. cit.*) states that No. 1 shaft at Edlington, brick lined throughout, was widened out at 399 yards until at 405 yards it attained a diameter of 24 feet 6 inches. It was continued at this diameter to 491 yards. It was brought in to 22 feet 6 inches at 495 yards and to 21 feet 6 inches at 545 yards, from where it continued at this diameter to the bottom. The object of the widening out was to reduce the friction of the air which developed at midshaft each time the cage passed. At 200 yards the shaft passed through a 6-foot fault, a 17-foot fault at 353 yards and large unproved faults from 566 to 605 yards and 875 to 892 yards. No. 2 shaft, also brick lined throughout, was widened out in a similar manner to No. 1. A 15-foot 6-inch fault was encountered at 714 yards and the shaft passed through a large unproved fault from 786 to 890 yards.

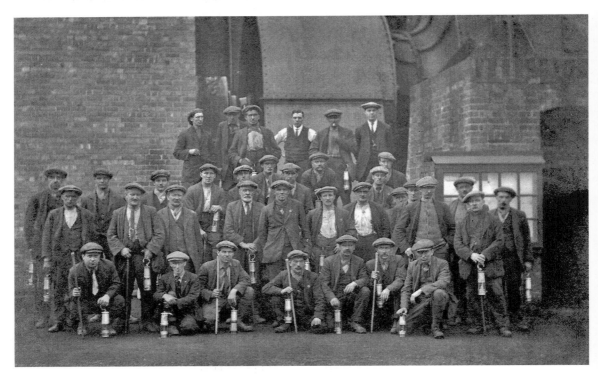

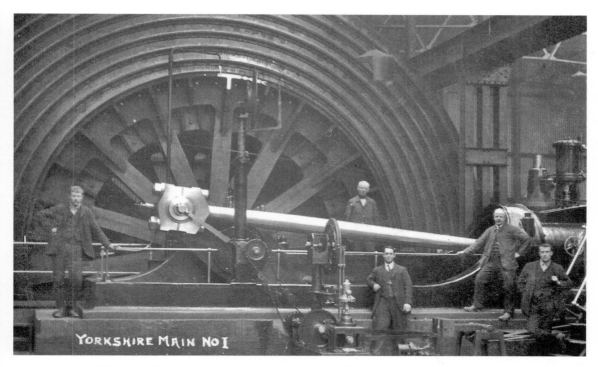

Above and below: The original method of working at Edlington was by longwall face, divided into tub stalls. The coal was then hand-filled into tubs on the coalface. Longwall mining is where a long wall of coal is mined in a single slice (typically 1–2 metres thick). The longwall panel (the block of coal that is being mined) is typically 3–4 kilometres long and 250–400 metres wide. In 1933, the 'tub stalls' system was replaced by the method of longwall advancing coalfaces, with conveyors along the coalface and a central roadway conveyor to transport the coal to a loading point on the main roadway in settled ground behind the working face. The top picture shows No. 1 shaft winding engine; the picture below shows the colliery yard with No. 2 shaft on the left.

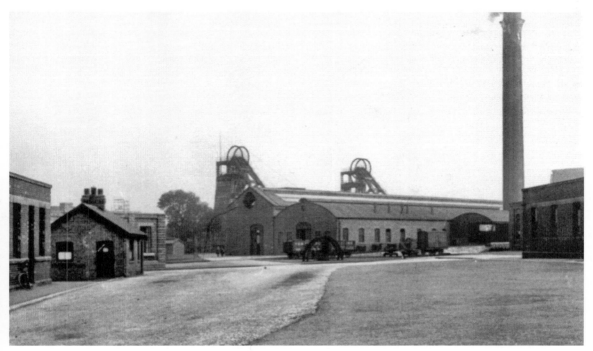

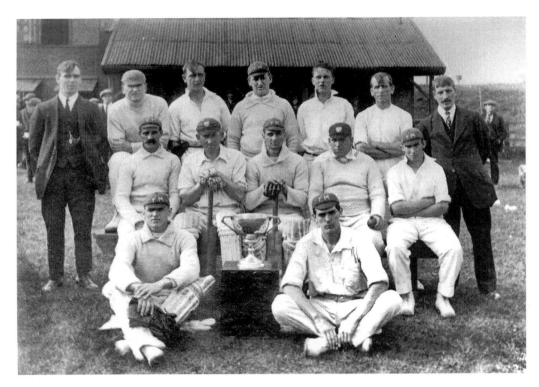

Above and below: Martin Gaskell stated in the *Town Planning Review* of October 1979 that Edlington had not been developed on the picturesque lines of Woodlands, but that the houses were well-built and convenient, with gardens at the front and yards at the rear. According to Professor Patrick Abercrombie, joint author with T. H. Johnson of *Doncaster Regional Planning Scheme* (1922), the way in which the work was carried out 'left everything to be desired'. M. E. and A. Lawrence, in the Worker's Education Journal *South Yorkshire Historian* No. 1 (1971), described the scene at the time of the houses' construction: 'The first street of houses to be completed was given the name of Staveley Street, and for a time the village was known to the outside world simply as Staveley Street. The roads were like a quagmire, as bricks for the houses were brought from Conisbrough and Balby by traction engines.' The picture above shows Edlington Yorkshire Main cricketers; the picture below shows a scene in Duke's Crescent with Victoria School in the background.

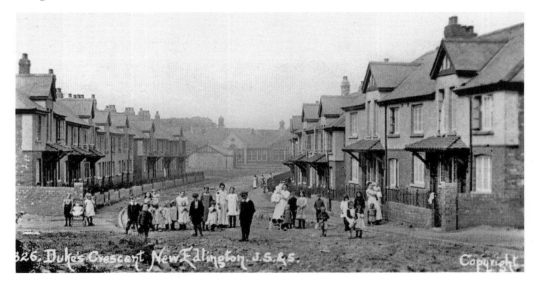

Above and below: Edlington's plans following nationalisation consisted of the introduction of underground locomotive haulage using large-capacity mine cars, skip winding plant at No. 2 shaft and a subsidiary mine car winding plant at the No. 1 shaft. The changes in the winding plant entailed alterations to the surface coal-handling equipment between the shaft tops and the preparation plant. While the new roadways were being driven underground, detailed design of the plant was being completed and orders placed and, as work progressed on the mining developments and on the surface, the installation of locomotive haulage proceeded in stages, using the existing pit tubs for conveyance of the coal. Consequently, in the years immediately following nationalisation (including the reconstruction projects), the colliery's net capital investment amounted to approximately £1,215,408. Both pictures show No. 1 and No. 2 shaft bottoms.

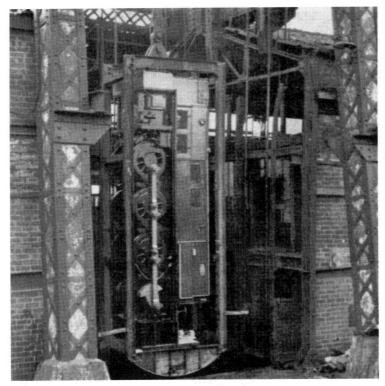

Describing the procedures for lowering two 15-ton, 100-hp locomotives down one of the Edlington shafts, the *Don. Chron.* of 10 August 1950 said: '[They] were run along a temporary railway line to the side of the shaft. Then began the task of fitting the first into its steel girder "sling". Inch by inch, under the direction of Mr Bert Hall, the colliery engineer, the heavy diesel was persuaded by workmen using levers and manpower, into its temporary cradle. The cage was removed from the winding rope and the cable attached to the diesel's "sling". Ready for its 840 yards journey down the shaft the locomotive was left while engineers checked on the winding engine and brakes.'

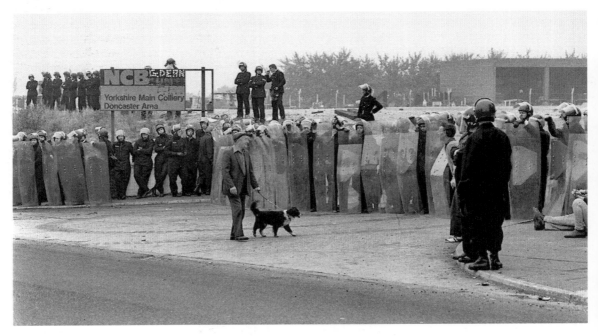

In April 1984, a few weeks after the national pit strike had started, Doncaster Council leader Jim McFarlane called into question police tactics in dealing with the miners. The Police Federation county chairman, Bob Lax, ripped into the county council and county police committee, who were holding an inquiry into the police handling of the miners' strike. He said, 'It is time the officers who have to perform picket line duties had a bit of moral support for the lousy job they have to do in trying to maintain the democratic rights of people who want to work.' Pickets and police are seen at Yorkshire Main Colliery, Edlington, on 22 August 1984.

Right and below: In January 1980, NCB national headquarters shelved a £26 million development scheme for the pit because of poor performance. That led to fear among union officials that the pit would close within twenty years; they claimed that it was already being run down. 'We are very concerned for the future of Yorkshire Main,' said NUM branch secretary Ian Ferguson. Five years later, men on the production shift at Yorkshire Main came to the surface for the last time on Friday 11 October 1985. As the men came to the surface, many expressed regret about the closure, which had devastated the community. 'I was born opposite the pit gates and worked here for 30 years,' said Lenny Dunford, aged forty-six. 'It's a very sad day for us all and I'm sure it will affect the village very badly.' Others blamed the Coal Board for the loss of the pit. Said one: 'The Board didn't want to keep the pit open. You can't blame the union because you've got to fight for your jobs or it's a waste of time.' The top picture shows Yorkshire Main on 14 December 1983; the picture below shows miners on the last shift.

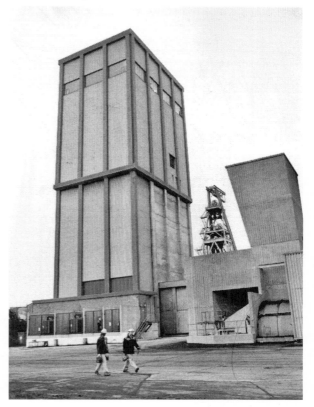

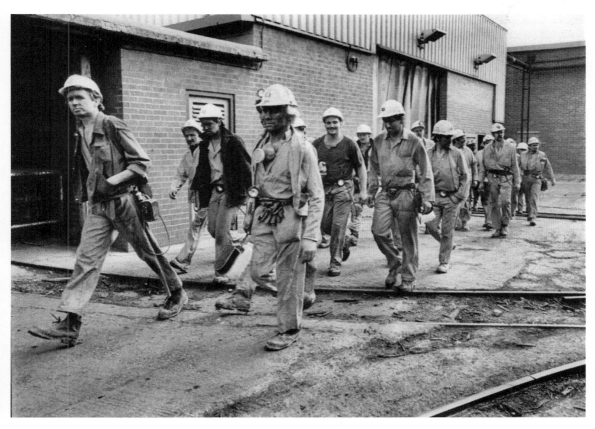

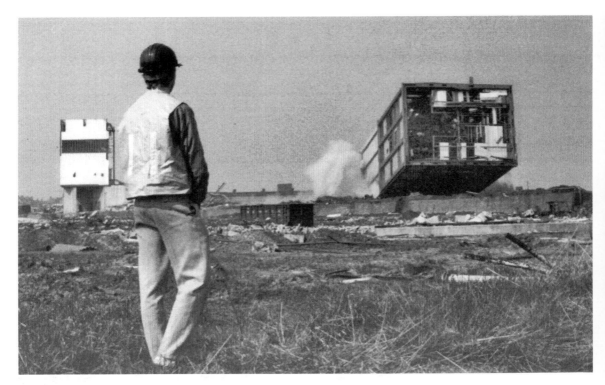

Above and below: In December 1991, a memorial to the men of Yorkshire Main and their families over seven decades was erected. Generations of Edlington men worked, were injured and even died at the pit upon which the village depended. A pit wheel, salvaged from the old colliery site, now stands in silent tribute on a plinth outside the Officials' Club. An inscription on a plaque reads: 'Yorkshire Main Colliery stood on this site from 1910 – 1985. A tribute and memorial to all who died in accidents here or whose lives were shortened by disease, injury or sickness, and to their families. Their contribution to the energy needs of the nation and the developments of Edlington must not be forgotten.' Edlington Town Council, the Officials' Club and developers of the old colliery site had co-operated in the memorial's erection. Much of the old colliery site has been redeveloped and is mainly occupied by housing. The top picture shows No. 2 headgear being demolished on 23 April 1987; the one below shows site clearance during the 1990s.

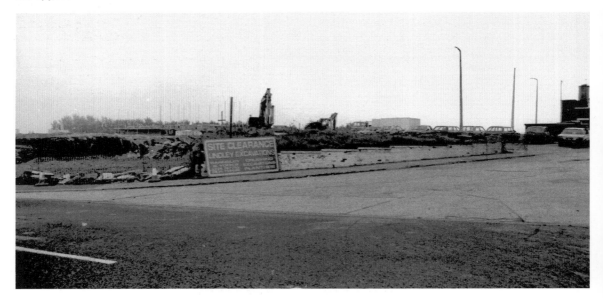

Hatfield Colliery

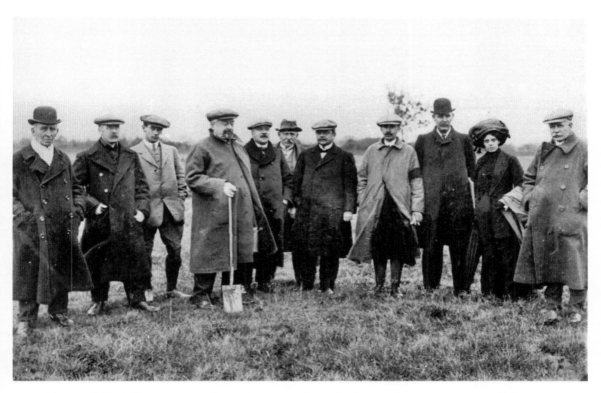

The Hatfield Colliery Co. was formed towards the end of 1910, but it was not until Thursday 4 October 1911 that the first sod of the new colliery was formally cut, while the sinking proper did not begin until 1912. In a report on the sodcutting ceremony, the *Don. Chron.* of 5 October 1911 wrote: 'A small company of directors, officials, mining engineers, with some of the neighbouring people, numbering about fifty, assembled in the large field where the work is going on ... Shortly after 12.30 in the afternoon Thomas Townrow, of Chesterfield chairman of the directors of the company stood in the centre of the ring, which marked the spot where number one shaft is to be sunk, and with a brand new small digging spade he cut the turf in an oblong, and putting his spade beneath it, turned it over. Mr Townrow then went to the other shaft site, followed by the company [of other officials] and performed a similar operation. In a short speech he said coal would not be reached before 800 or 900 yards had been sunk. A good many difficulties would have to be contended with, and a good deal of work to be done by the mining engineers ... when finished the diameter of the two shafts will be 22ft, and when the pit is completed there will be twelve boilers laid down. It is the intention of the company to work the Barnsley seam of coal. The seam is 8ft thick and it is hoped to be able to work between 5ft 6in and 6ft. The contractors' period of time for sinking the colliery, from the present date, is two years and nine months ...'

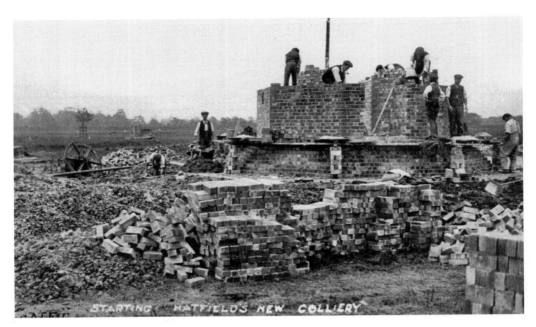

Above and below: No. 1 shaft at Hatfield reached the Barnsley Bed on 15 August 1916, at a depth of 852 yards. It was completed to a depth of 881 yards on 11 September 1916. No. 2 shaft was completed on 1 April 1917 at a depth of 872 yards. There was a delay of about twelve months in this shaft owing to water difficulties. Pickersgill (*op. cit.*) states: 'A small depth of running sand was encountered at the commencement of the sinking which was piled through. The first 180 yards of sinking was in the Triassic Sandstones and the cementation process was adopted. The upper 108 yards in No. 1 and 65 yards in No. 2 shaft were carried out by Messrs Francois Cementation Co. and later the work was carried out by the colliery company. Below 184 yards ordinary methods of sinking were adopted. The shafts passed from the Permian to the carboniferous measures at 354 yards from the surface ... Both shafts are lined throughout with concrete ... Two seams are worked, the High Hazel at 774 yards and the Barnsley Bed.' The top picture shows construction work on some of the buildings at Hatfield Colliery, the one below preliminary work taking place.

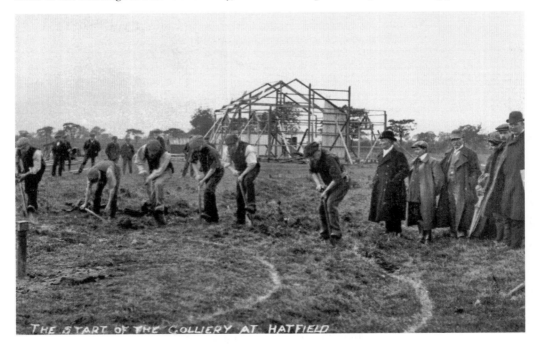

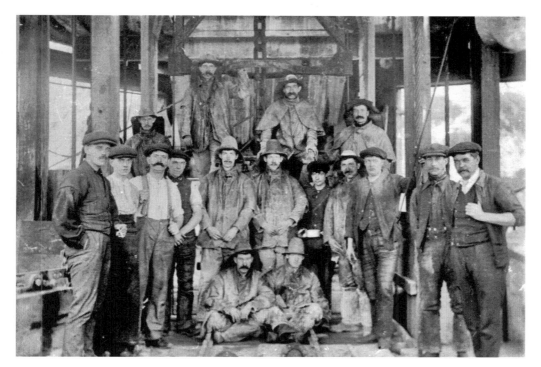

Above and below: Reporting on Hatfield Colliery's progress, the *Don. Chron.* of 21 March 1912 stated: 'The headgear for one of the shafts is now being erected, and when this is finished the other will be commenced. In March 1915 it was announced that work at Hatfield Colliery had been affected a good deal by the War. It had also affected the supply of material. On 9 April 1915, the *Don. Chron.* said that a sad fatality at the colliery had broken the record of almost complete immunity from serious accidents which the pit had enjoyed. The pictures depict sinkers proudly posing for the camera and hard at work in one of the shafts. www.stainforthonline.co.uk states: 'The clothes and hats worn by the 1st sinkers were made of unbleached calico, soaked in linseed oil for a week then dried. The water would then roll off them.'

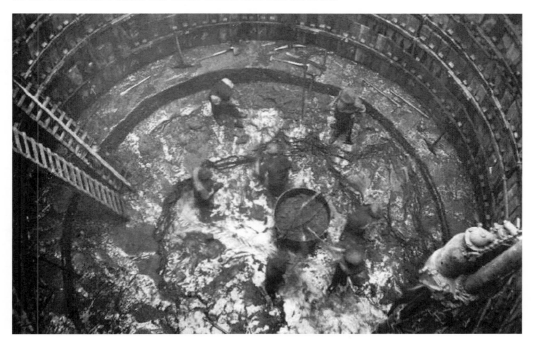

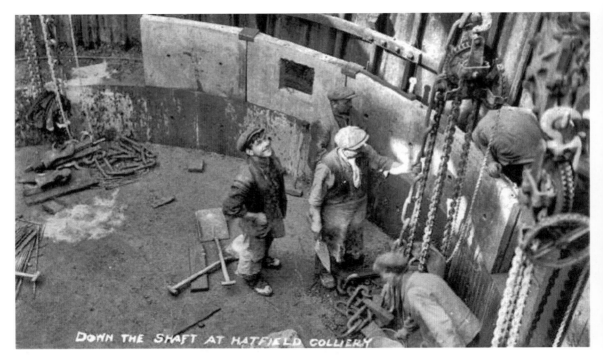

Above and below: On 28 March 1930, the *Don. Chron.* said Hatfield Main was developing quickly and promised to be the biggest pit in the Doncaster coalfield area and the only 'new' colliery working two seams simultaneously, the Barnsley and High Hazel. It had obtained several foreign orders, and management required 600 more employees. In 1930 there were 3,600 employees at the colliery, but the management said they could find work for 500 more coal getters and 100 other hands. The weekly output exceeded 20,000 tons. 'A big problem in staffing these new pits was that of housing, and although Hatfield had built 1,471 houses and Thorne Rural Council nearly 300 in the neighbourhood, there was still need for many more. The rural council had a scheme for building 200 as soon as possible,' said the newspaper.

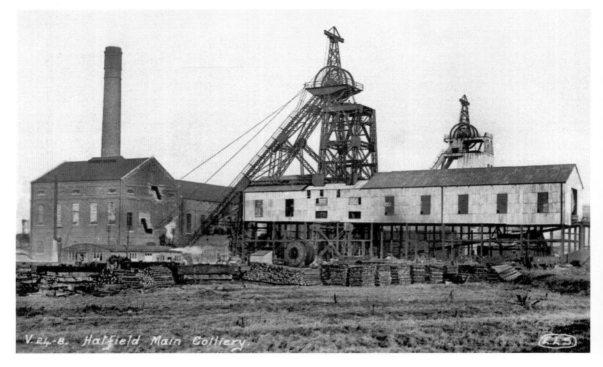

Above and below: One man died and over fifty were injured in a cage crash at Hatfield Main Colliery on 12 December 1939. Most suffered fractured limbs, and amputations of legs were necessary in the case of ten men and boys. A Doncaster jury returned a verdict of accidental death at an inquest on Friday 15 March 1940 on Daniel Horrigan, a stoneworker of Arundel Street, Stainforth. The accident was due to overwinding of the cage when the men of the morning shift were being raised to the surface and men on the afternoon shift were being lowered into the mine. At the time, fifty-nine men were being lowered, thirty of them on the top deck of the cage and twenty-nine on the bottom. Coming from the pit bottom were twelve men, all riding on the top deck. It was probably the last journey of the cages during the changeover. During this winding something went wrong and instead of the descending men being lowered gently, the cage hit the pit bottom with force. The jury told coroner W. H. Carlile that the safety gear did not cover a sufficient margin of error. The top picture shows miners' houses in Broadway, Dunscroft, Hatfield; the picture below shows Hatfield Main from the air.

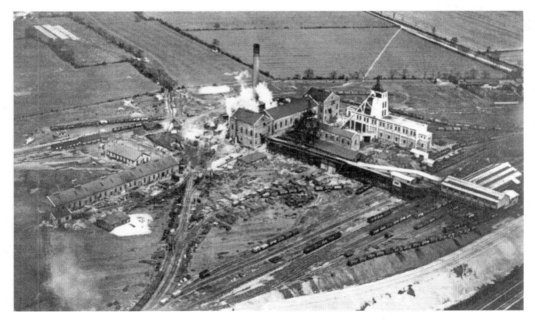

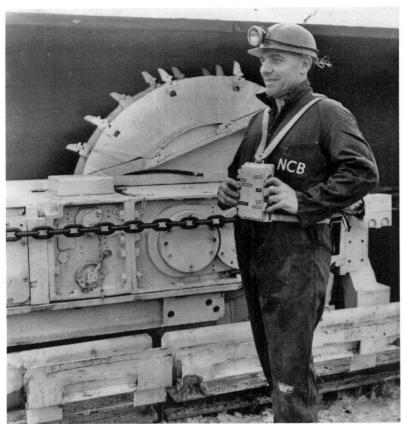

'Now it is coal cutting by radio control,' said the *Sheffield Telegraph* on 20 October 1967. The prototype, evolved by Coal Board scientists, had been shown in a surface set-up at Hatfield Colliery the previous day. For the demonstration to pressmen, a forty-five-year-old face worker, William Pearson, was whisked out of the pit, and given half an hour's instruction. 'What the radio control means is that the operator of the cutting machine will not have to stay with, weaving among pit props, alongside the machine's controls. He can be ahead of it or behind it,' said the newspaper.

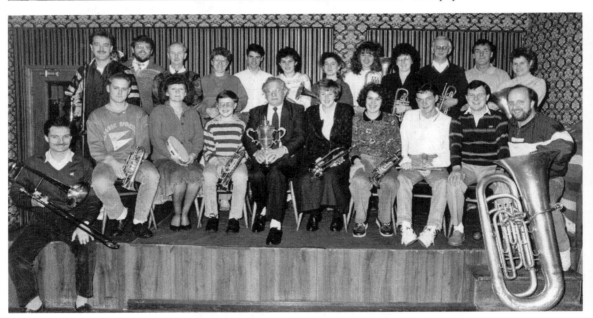

The Hatfield Colliery band faces the camera prior to a practice in the King George Hotel, Stainforth. The band was formed in 1947 by two colliery workers, Mr J. G. Hedley (Geordie Hedley) and Mr J. Rigby.

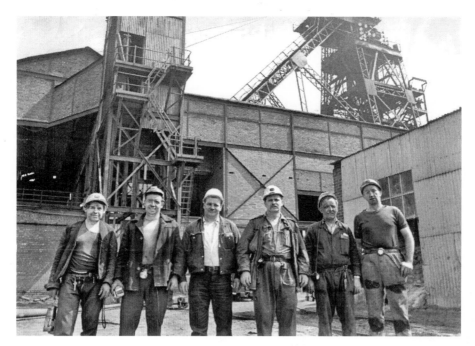

Above and below: '[Hatfield Colliery] has become the first in the country to take on a Swedish look in the pithead baths,' wrote the *Sheffield Telegraph* on 6 May 1971. The idea for the sauna came from miner John McGarvey, who told the pit's consultative committee how impressed he had been by sauna baths on a tour of Scandinavia. The committee, comprising NUM officials and colliery bosses, investigated the suggestion and later decided to go ahead and spend £500 on a sauna bath made by a Doncaster firm. 'The money has come from the charity and welfare fund which is jointly run by the union and management,' said Frank Clark, Hatfield NUM branch secretary. But while the men sweated it out in the sauna – as many as twelve at a time – women and girls employed in the offices and canteen were told there was no hope of them being allowed to use the facility.

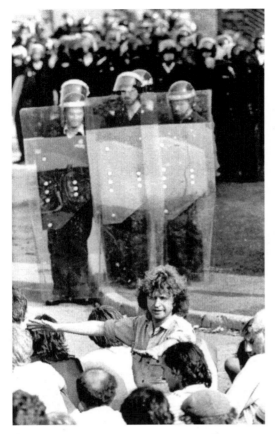

Left and below: On www.stainforth-va.co.uk, under the heading Strikes and Strife, the following details are given: 'The miners of Hatfield Main played a major part in the strikes of '69, '72, '74 and finally in '84, where Tory trickery was used to fool those of lesser gumption into crossing picket lines for the first time at Hatfield. After the '84 strike, the strength of the NUM at Hatfield declined. By the '90s, after the pit had been bought by the previous management, the Union was no longer made welcome on the site of the colliery.' Dave Douglass in *Pit Sense versus the State* (1994) adds: 'Participants in and readers of the history of the Doncaster coalfield are at once struck by the repeat of events between the 1926 strike and the 1984/85 strike. It is quite uncanny to discover that not only are the self same scenes repeated but often in the exact same locations.' In the top picture, Hatfield Colliery NUM delegate and author Dave Douglass (centre) is pictured on the picket lines at Hatfield Colliery during the 1984/85 Miners' Strike. The picture below shows miners at Hatfield Colliery on 4 January 1984.

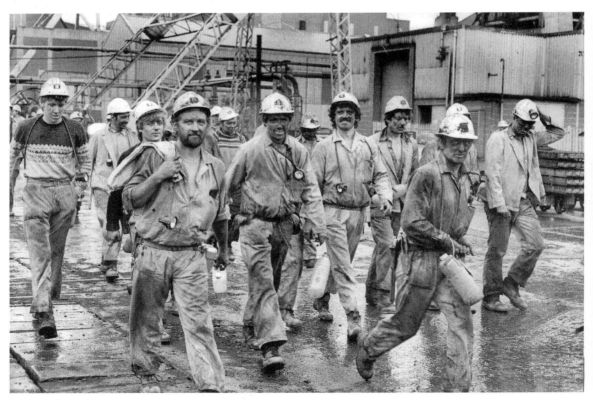

In 1967 the Hatfield and Thorne collieries were merged, becoming separate again in February 1978. They were merged again on 1 February 1986. On 18 November 1993, it was announced the combined pit would close, which took place on 3 December 1993, when under the ownership of British Coal. The above picture shows the scene at Hatfield colliery on that 'last' day. On 4 January 1994 a team from the pit's management announced they wanted to reopen the pit, forming Hatfield Coal Company Ltd on 25 January 1994. The first coal was dug on 7 July 1994. In its first year of operation, the company made a profit of £2.4 million. On 9 August 2001 the company went into receivership. The firm employed around 200 people.

Wikipedia follows subsequent developments at the colliery: 'In October 2001, Richard Budge, former owner of RJB Mining, took control of the pit, under ownership of his company Coalpower. Coalpower went into administration in December 2003, then liquidation on 22 April 2004.' Richard Budge (fifth right), chairman of Coalpower, is pictured at Hatfield on 8 October 2001 alongside Doncaster North MP Kevin Hughes (centre), Doncaster Council leader Councillor Martin Winter (fourth right) and members of the workforce.

Left and below: Wikipedia also states: 'In 2006 Richard Budge formed his Powerfuel company, who own the mine. Powerfuel is 51% owned by Kuzbassrazrezugol (KRU) for which it paid £36m. Powerfuel is a member of the Confederation of UK Coal Producers.'

On 6 May 2011, the *Don. Star* added the following: 'Administrators at Powerfuel Mining have confirmed they have sold Hatfield Colliery to a new Dutch-registered holding company. The pit, its 393 employees and 11 staff from parent company Powerfuel plc were transferred into a new firm, after Brian Green and Richard Fleming, from KPMG, were appointed as administrators by Powerfuel. They were called in after bosses at Powerfuel were unable to find cash needed to carry out work at the pit and to fund the development of a clean coal power station next to the mine. The new firm, Hatfield Colliery Ltd, has now been sold to Entero BV, a recently established holding company. Mr Green said: "The transaction saves hundreds of jobs in an area that has a long tradition of mining employment, and puts the business on a solid footing." The colliery is being funded by ING Bank and will continue to be run by managers transferred across from Powerfuel Mining with support from Hargreaves Services, which runs Malby colliery. Powerfuel was put in administration in December [2010].' The picture to the left shows Hatfield Colliery procurement manager Jamie Wilson (left) and fitter Terry Carley in April 2007; the picture below shows Richard Budge, chairman of Coalpower, chatting to workers at the colliery on 8 October 2001.

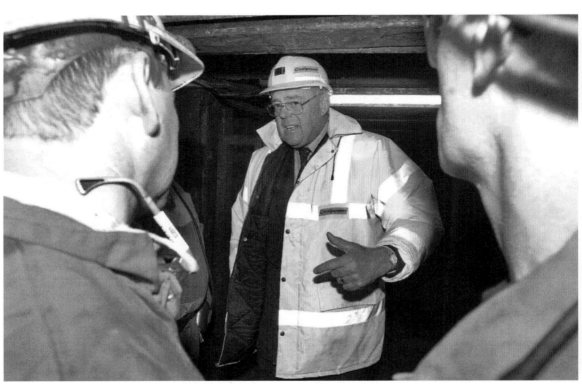

Hickleton Colliery

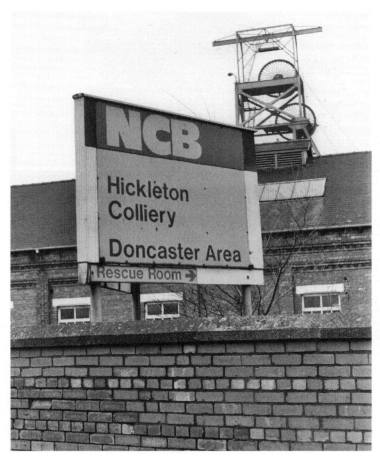

The *Don. Chron.* announced on 6 July 1894 that coal had been reached at the new colliery at Hickleton, belonging to the Hickleton Main Colliery Company Ltd, and that plant was being put down to deal with a daily output of 2,000 tons. The bed was between 7 feet and 8 feet thick and at a depth of 540 yards. The newspaper added: 'The preliminary operations at Hickleton were commenced in December 1892 and after water had been got through, coal was reached under 12 months, the sinking being carried out at the rate of over 13 yards per week. Already a large number of houses were erected and others were about to be built in Thurnscoe and Goldthorpe ... Sinking operations were conducted under the direction of C. Walker. The mine warding engines were made by Davy Bros of Sheffield and the sinking engines by Markham & Co. of Chesterfield, whilst the pumping engines were made by a firm at Carlisle. Electricity was largely used for shot firing and for lighting the shafts during the sinking operations.'

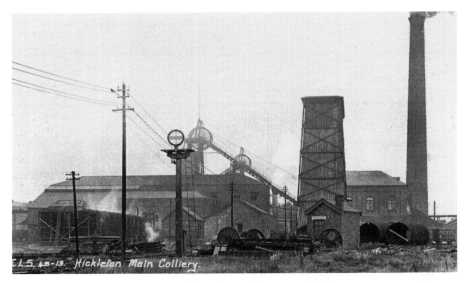

Tracing the early railway links to the colliery, A. L. Barnet, under the heading the Hull and South Yorkshire Extension Railway in the *Railways of the South Yorkshire Coalfield From 1880*, explains: 'In 1895, the proprietors of the Hickleton Main Colliery ... approached the H[ull] & B[arnsley] R[ailway] board with a view to that company building a branch to the colliery, an invitation which was declined. The mineowners then decided to proceed on their own account and deposited a bill. The Hull board thereupon relented and promised to help ... The H&BR board decided upon a double line from Wrangbrook to Hickleton Main ... the contract being let to Walter Scott & Co., in June 1899. At the 'cutting of the first sod' by Mrs J. Fisher at Wrangbrook on 26 July, it was said that the branch would serve Hickleton Main, Manvers Main and Wath Main Collieries ...'

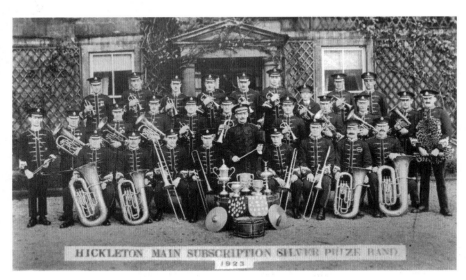

On www.brassbandresults.co.uk it is evident that the Hickleton Brass Band played under a number of names, including Hickleton Main Ambulance Band, Hickleton Main Band, Hickleton Main Colliery Band, Hickleton Main Public Band and Hickleton Main Subscription Band. Among the former conductors were T. Hunter, Harold Evans, George Thompson, F. Webb and W. Worton. The band was seemingly operational between *c.* 1922 and *c.* 1961 and is seen here in 1923. On www.ibew.org.uk (a website detailing extinct brass bands), it is recorded: '[Hickleton Main Colliery Band] Active in the 1920s. Successful in competitions in the 1940s and 1950s. Herbert Batty was a cornet player with the band. They wore smart uniforms, green tunics with gold facings, black trousers.'

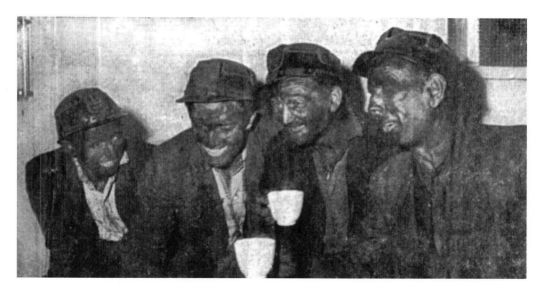

Crowds at the pithead at Hickleton Colliery cheered on the evening of 11 October 1960 as seven miners who had been trapped for 18 hours in a 25-yard space 2,400 feet underground were brought to the surface. With a good hot mug of tea to warm them, four of the rescued miners could still manage a grin for the *Sheffield Telegraph*. Left to right: Raymond King, Eddie Fitton, Tom Brockhurst and Reg Knapper.

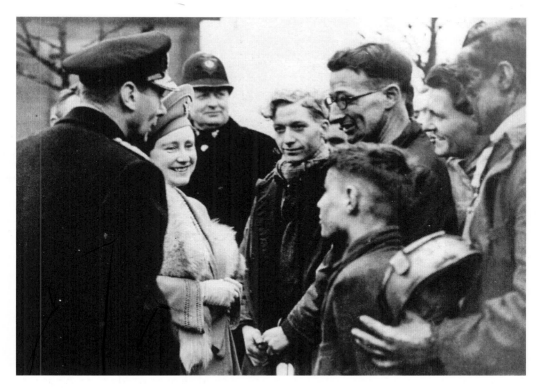

Throughout the Second World War, King George VI and Queen Elizabeth made morale-boosting visits throughout the United Kingdom. The last visit made by the King to the South Yorkshire area was on 9 February 1944, and when visiting Elsecar Colliery he had eaten his meals with the rest of the men in the pit canteen, laughing and joking with them. He then went on to Hickleton Main Colliery, where he walked among the 'black-faced colliers', shaking them by the hand and telling them how pleased he was with them, and how important they were to the war effort.

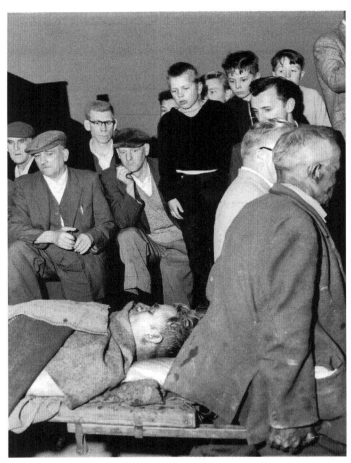

Left and below: Terror struck Hickleton Colliery on 24 September 1962 when a forty-year-old miner died, buried beneath rubble. Frantic efforts by colliery rescue workers saved the lives of five other miners, but wives and children who stood a nine-hour vigil at the pit gates were stunned as news of the death of bachelor miner Charles Littlewood reached the crowd. The men were buried when about 20 feet of roof in the Parkgate seam suddenly collapsed without warning, showering down a cloud of dust, rock and coal. Two of the trapped men were rushed to hospital and detained. Both pictures here were taken on the same day; the top one shows miners looking on as Harry Pickering is taken to an ambulance. On 5 June 1964, two men were killed in a pit top conveyor belt accident at Hickleton Colliery. The victims were repairing the steel conveyor belt leading to the washing plant when the belt started up suddenly. Fifty-two-year-old Louis Crossley and Arthur Longbones, aged fifty-seven, were killed.

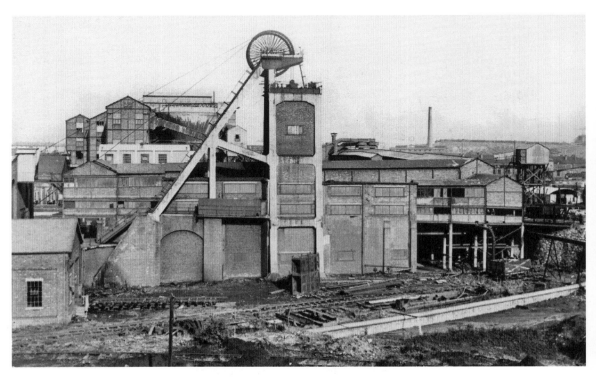

During his working life at Hickleton Colliery, face worker Tom Barrett staged several protests. On 8 October, the *Sheffield Star* reported: '[Tom, aged 58, is] staging a hunger strike more than 700 yards below ground ... It is believed ... [he] is protesting at the political levy to the Labour Party which is deducted from his union subscription.' Later, he took his 'hunger' protest to the NUM headquarters in Barnsley. But his hunger strike was ended when, according to the *Sheffield Star* of 14 October 1981, a doctor threatened to call an ambulance to him. He is pictured outside Hickleton colliery in May 1981.

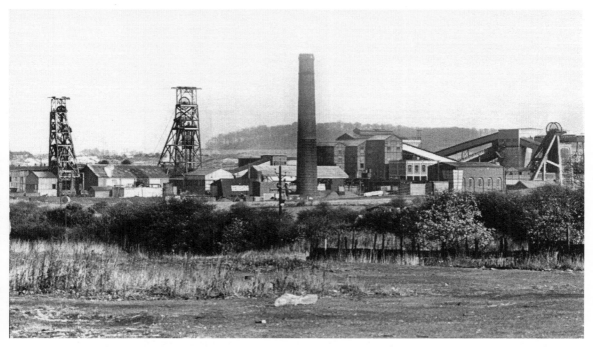

Panoramic view of Hickleton Colliery, 30 October 1972.

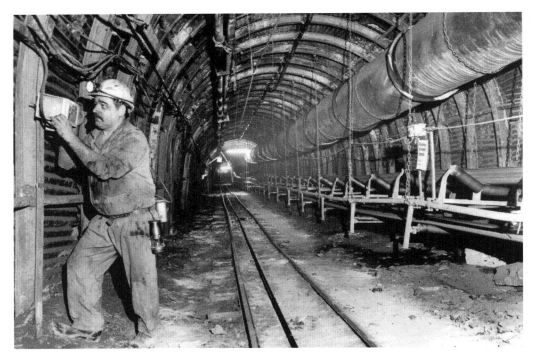

Underground roadway at Goldthorpe-Hickleton Colliery, September 1986.

Hickleton Colliery branch secretary Brian Conley is pictured in 1983 when speaking out against the NCB's plans to put Hickleton on a development-only basis for two years. He was worried that the whole fabric of the mining community around Hickleton Colliery would crumble if the men were despatched to other pits – albeit temporarily. 'It is not that we distrust management at the colliery, or at the area. It's in London that we see our suspicions to be well founded,' he said. Unfortunately, he was right. On 18 June 1987, the *Don. Star* announced that production was to stop at Hickleton Colliery and the entire workforce was to be either transferred or made redundant. The decision was made by British Coal at a colliery review meeting. The colliery had been working on a development-only basis since March 1985, but plans to complete work on it had been scrapped. The workforce at the pit had already been slashed from 1,200 to 91. In April 1993 a memorial to the colliery – a winding wheel on a stone plinth – was unveiled near the former pit entrance.

Rossington Colliery

The first turf was cut in preparation for the sinking of Rossington Colliery on Monday 10 June 1912. The new colliery was the joint enterprise of the Sheepbridge Coal & Iron Co. and Messrs John Brown & Co. A large gathering was invited to witness the proceedings, including mining magnates and officials from the railway world. Union Jacks fluttered in the breeze. In the centre of the throng stood Mrs Maurice Deacon (wife of the managing director of the Sheepbridge Iron & Coal Co.) and Lord Aberconway, the chairman of Messrs John Brown & Co. His lordship handed to Mrs Deacon a handsome silver spade on behalf of the company.

 Mrs Deacon cut the turf amid a hearty cheer. Soft as the ground was after some rain, the spade buckled in the process, but Mrs Deacon reversed it and succeeded in getting it straight again. Later, more than 100 guests sat down for luncheon in the temporary colliery offices. It was anticipated that the Barnsley seam of coal would be reached at a depth of 800 to 850 yards. No. 1 and No. 2 shafts were completed in 1915 and the first coal was brought up in that year.

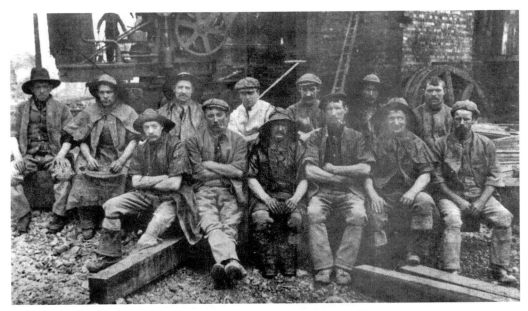

The *Don. Gaz.* of 1 August 1913 said that the pastoral calm which has brooded for so long over the woods and meadows around Rossington was already giving place to the bustle and hustle that came in the wake of colliery enterprise. The boundaries of the Rossington colliery village 'make an irregular four-sided figure, but the greater part of the houses are planned in perfect concentric circles ... The inner circle consists of the officials houses, these being semi detached villas facing a central park. The second circle is formed of workmen's houses of a superior type, and the third and outermost circle of somewhat smaller houses, both of these being set in blocks of from four to ten houses each. Outside this circular formation there are streets of houses running at a tangent on the west and east sides respectively ... the whole of the village is being built by Messrs Hopkinson & Co. of Worksop ... Altogether some 840 houses are to be erected on this site.' Workers are seen at Rossington Colliery in the early stages of its development.

A Rossington Colliery cricket team.

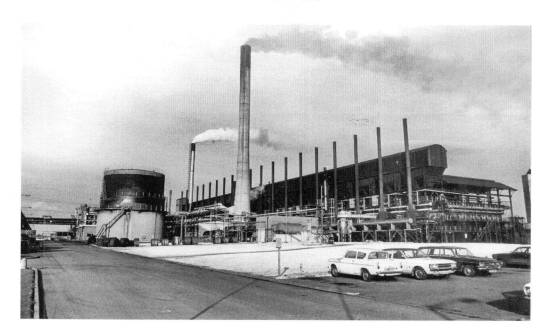

Above and below: In 1969, Coalite opened a foundry at Rossington to produce coke and employed between 300 and 400 people. Much opposition was voiced about the plant's existence, as recalled in *The Villager*, December 1992: 'The company was polluting our atmosphere around Rossington and Bessacarr with 9 tons of sulphur chemicals every twenty-four hours. Around our area and Bessacarr, flowers were turning a totally wrong colour to what they should have been, trees were thwarted in growth, and there was a rise of 3,000 chest complaints around the area, while the plant was operating ... When the plant closed in 1974 there was an inquiry, which was to last for three months, it was revealed the chemicals used in producing the coke were the same chemicals used in the Vietnam warfare. They closed their doors suddenly, saying it was due to a fall in sales.' The top picture of the plant was taken on 26 February 1976; the one below was taken on 22 September 1972.

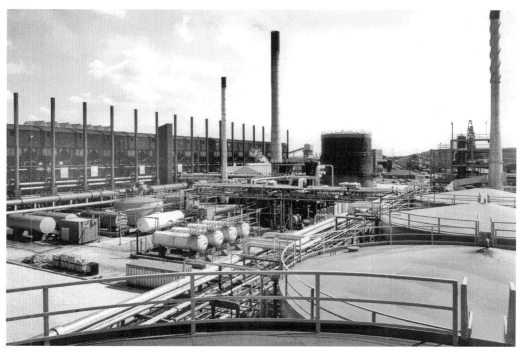

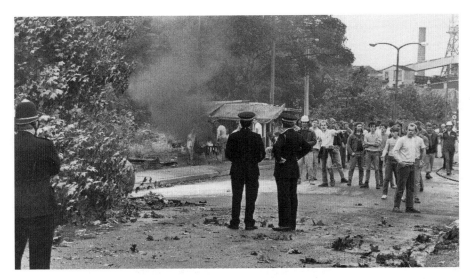

Above and below: On 9 July 1984, angry pickets turned up at Rossington Colliery to thwart management safety teams from other areas carrying out underground inspections. Trouble flared on the arrival of thirteen members of the British Association of Colliery Managers. The NUM was also angry that NCB area manager Albert Tuke had sent a letter to strikers the previous week urging them to return to work. Pickets chopped down two large trees from the nearby wood, using one to block vehicles carrying the thirteen men. Later, 200 police stormed the barricade, gaining entry in an NCB van for the men. Once the police had gone at 10 a.m., the barricades, including fencing, metal bicycle racks and barbed wire, were erected again by pickets. Throughout the day, members of management staff were unable to leave the colliery control room. By late afternoon, more than 1,000 people poured into West End Lane, approaching the pit. The NCB van which had taken the thirteen men into the pit was pushed towards the barricades, tipped over and burned. At 7.30 p.m., Mr Tuke asked the police to get the thirteen men out. They drafted in 500 officers and drove two police riot vans towards the pit entrance, picking up the managers. They left in a hail of missiles. Both pictures capture scenes from 9 July 1984.

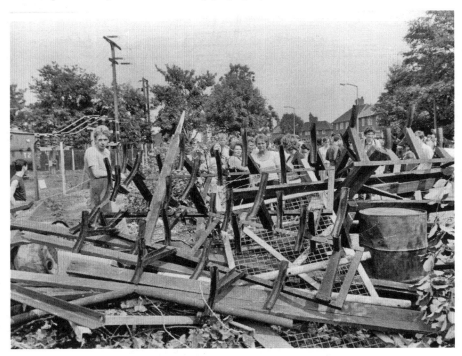

Terry Watson, in charge of the police operation at Rossington on 9 July 1984, said that the BACM men were terrified as pickets tried to break into the colliery control room. There were no arrests during the siege and only one minor injury to a police officer. He praised the work of the local NUM officials in trying to calm the pickets. Afterwards, Mr Tuke told the press that the NCB would abandon Rossington until the NUM agreed to change tactics. Jack Taylor, NUM, responded: 'This anger and ill-feeling was caused because the Coal Board sent letters over the union's head and I hope they will reflect on that.' The photograph shows another scene at Rossinton on 9 July 1984.

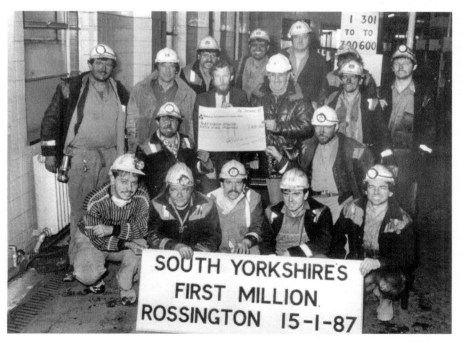

'It's all smiles at Rossington after the pit became the first in South Yorkshire to produce one million tonnes of coal in the current financial year,' said the *Don. Star* of 21 January 1987. The 1,200 miners at the colliery brought up the magic million in just nine months. British Coal officials said the hard work of the men, allied to the introduction of new technology and improvements in coal transport, had helped bring production costs down to among the cheapest in the country. To share its success, the colliery donated £65, the price of a tonne of coal, to the amenities fund of Rossington's Gattison House pensioners' home.

Rossington Colliery gym, seen in August 1990.

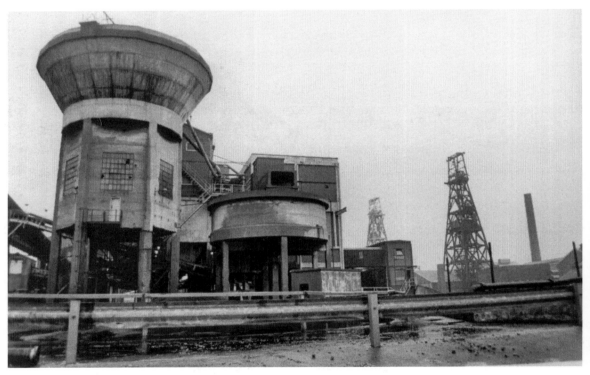

In *The Villager* of November 1992, Jan Chessman described life at the pit in the lead-up to the 'mothballing' in 1993 and the take-over by RJB Mining in 1994: 'In 1991 there are now 844 men working, and the colliery is recruiting for the first time in a number of years. November's total weekly tonnage of coal brought up was 23,700 tons. They usually average 25,000 tons a week, and they need 20,000 to break even, there are two coalfaces in production today and the coal is still 900 yards down. The only problem in this industry today is the imported coal, and it's having a major affect on the coal industry, although at the moment Rossington has not been affected too much, but if the National Coal Board goes back to private ownership, and the power stations go into buying more and more cheaper coal, then it will affect one of the biggest industries of our time.' Rossington Colliery is pictured on 4 February 1986.

On 26 March 1993, the *Don. Star* announced that the news Rossington Colliery was to be mothballed had been greeted with anger and dismay by villagers. Rossington NUM secretary John Gibson said in the newspaper: 'We thought we had a good chance of keeping Rossington open because we have transformed the pit since last October. We have been breaking output records – we broke one only last week – and the coal has been selling very well. It doesn't make sense.' Later in the year British Coal sought a private buyer for Rossington Colliery, and on 21 March 1994 the *Don. Star* announced that the colliery had been reopened by RJB Mining plc under a ten-year lease. *Wikipedia* states: '[RJB Mining] was founded by Richard J. Budge in 1974 ... In 1994, following the privatisation of the UK mining industry, it grew fivefold with the acquisition of British Coal's core activities. It changed its name to UK Coal in 2001 after the retirement of its founder.' Rossington Colliery is seen here on 5 November 2001.

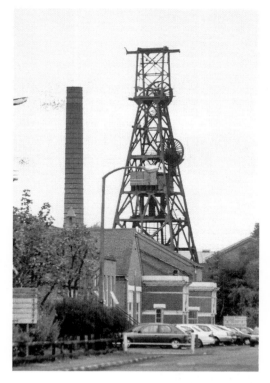

Bo Stannard, Andy Harrison and John Dowling with some of the last coal extracted from Rossington Colliery on Friday 31 March 2006.

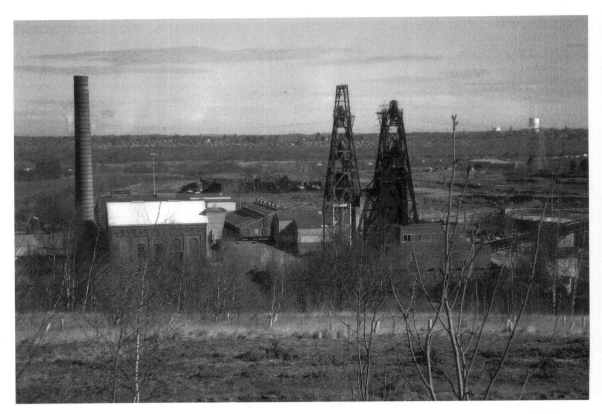

On Saturday 1 April 2006, the *Yorkshire Post* reported that hundreds of workers faced a bleak future after Rossington Colliery had ceased production on the previous day. 'UK Coal chiefs were forced to bring work at Rossington Colliery, near Doncaster, to a grinding halt after suffering multi-million-pound losses. For the next four weeks all 220 miners will still be kept on by UK Coal while they dismantle the pit equipment.' UK Coal chief executive Gerry Spindler said: 'The men at Rossington have done an excellent job, often in geological conditions more difficult than any you experience in mining elsewhere in the world. There are still reserves remaining at Rossington, but they require a major investment which we just cannot finance at this time.' The NUM said: 'Rossington can still be a success, there are still millions of tonnes of coal underground, which could last for years but it looks like it's going down the pan.' Demolition work and site clearance was carried out at Rossington Colliery during 2007.

Thorne Colliery

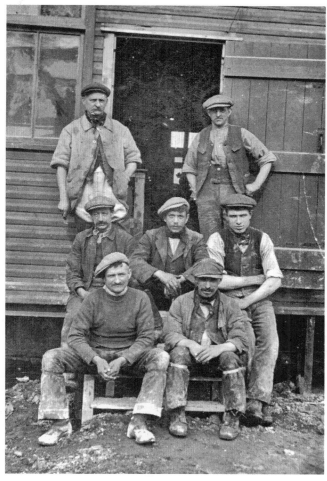

Pickersgill (*op. cit.*) states that the sinking of Thorne Colliery was one of the epic achievements of modern mining. It was carried through in the face of unparalleled difficulties over a period of seventeen years. Messrs Pease & Partners commenced actual sinking on 12 October 1909 with No. 1 shaft, No. 2 being commenced two months later. 'Each shaft is 22 feet in diameter finished. It was obvious that the greater thickness of water bearing Triassic Sandstone measures encountered as one proceeds eastwards would involve great expenditure of time and money, but nobody could foresee the great difficulties which did ultimately arise ... when No. 1 shaft was 478 feet and No. 2 567½ feet deep, the pumps could no longer deal with the feeders of water, although eight were slung in the shaft, and sinking had to be suspended.'

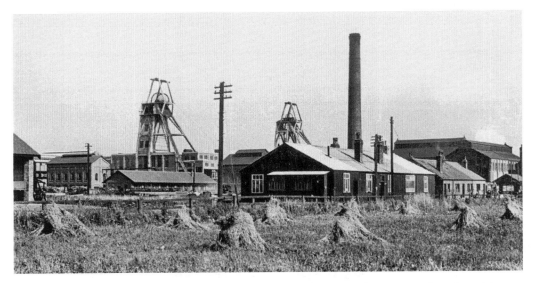

An attempt was made in August 1911 to keep back the water by cementation, but this was abandoned in December 1911 and sinking was suspended. Several efforts to continue sinking were met with more difficulties, not least the intervention of the First World War. Thereafter a variety of methods were tried, and Pickersgill recounts the following problems: 'Pump motors had burnt out several times, the shafts had been allowed to fill with water more than once to balance the hydrostatic pressure, there had been trouble with leaking crib beds, short lengths of tubbing had perforce to be used, one of the freezing bore holes had to be encountered, which gave a feeder of 400 gallons per minute, and there had been endless other troubles.' Yet success was achieved by March 1926, seventeen years after commencement of sinking operations.

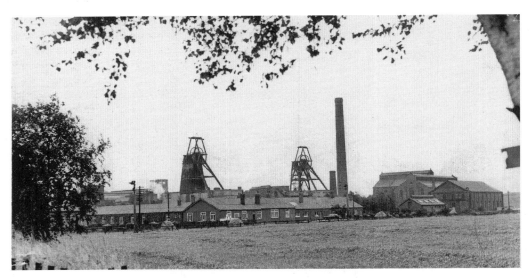

Thorne Colliery was worked until 1956, when production was halted and the workforce transferred to neighbouring collieries. www.minersadvice.co.uk relates: 'There had been a history of strained labour relations at the colliery, which was cited as adversely affecting productivity and profitability. There was also the problem of the increasing rate of water ingress in No. 2 Shaft which, by the time production was halted, had become intolerable. At the same time, part of the shaft wall collapsed and revealed a very significant cavity which made the shaft virtually unusable. Over a period of years, a temporary and then a permanent repair was made to the shaft, but this caused a reduction in the shaft's diameter.' The photograph illustrated a *Sheffield Telegraph* article on the colliery on 20 September 1968.

The stark news that Thorne Colliery was not to reopen was given to miners' leaders in Doncaster on Friday 5 January 1968. The workforce, who had travelled to other pits since 1956, when Thorne was closed for remedial work, would not be returning to their old jobs, said Peter Tregelles, the Doncaster area director. He also revealed that maintenance, which occupied 124 men at the colliery, would cease by September and the coal preparation plant, which had been treating coal from other pits, would be shut down by the end of next March. The coal preparation plant and other surface installations, including the winders, were to be demolished.

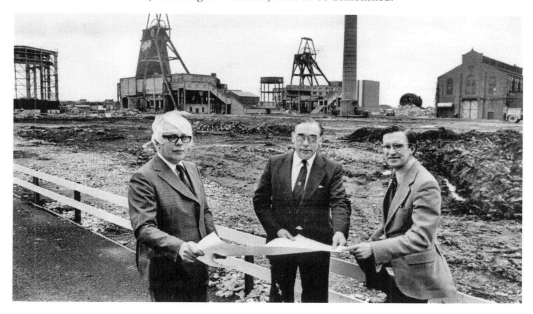

In an article headed '£180m Rebirth of Thorne Colliery', the *Sheffield Telegraph* of 27 March 1979 announced that the colliery was to be reopened and would be the largest coal-producing shaft mine in Britain by the mid-1980s as a result of a £180 million scheme unveiled the previous day. The pit's rebirth was announced by the NCB Doncaster area director, Jack Wood, following borehole tests to prove coal reserves. 'Work on sinking the new third shaft will start in the near future. The pit will begin by working the Barnsley seam, followed by the High Hazel. New pit bottoms will be constructed and 24 kilometres of main trunk roadways driven to establish all the new coal workings,' said the newspaper. Looking at plans on 26 March 1979 for the Thorne Colliery rebuilding programme, from left to right: Geoff Jackson, chief mining engineer for Thorne Colliery; Jack Wood, Area Director, Doncaster NCB; Dr Edmund Marshall, MP for Thorne. The photograph below shows an artist's impression of the proposed new Thorne Colliery surface.

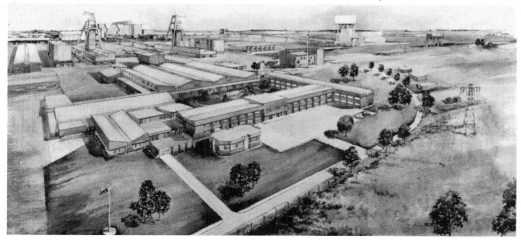

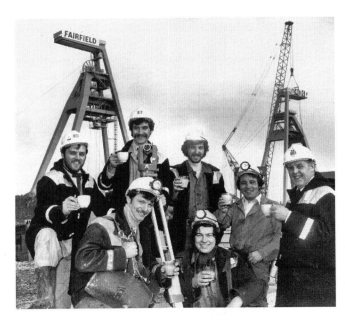

Workers at Thorne Colliery, pictured 13 January 1982.

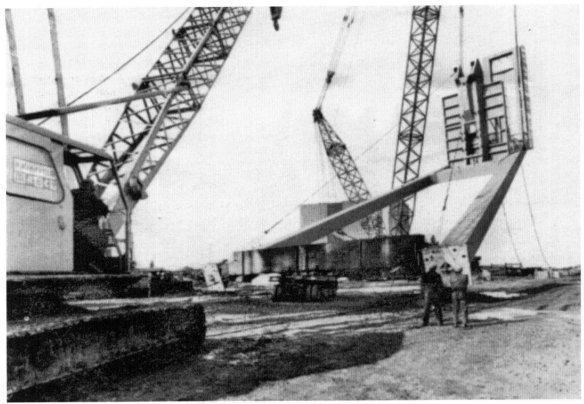

The *Sheffield Telegraph* (27 March 1979) said that the surface of the colliery was to be rebuilt and most of the coal transported by merry-go-round trains, although a new road being built from Moorends village, where the colliery stood, may take a third of its output. 'The colliery will have the industry's latest technology to work six faces with three shafts instead of the original two. It has known reserves of about 140 million tonnes within a five mile radius of the pit and a life expectancy of between 50 and 70 years,' said the newspaper. The photograph illustrates upending the first A-frame in the lifting trapeze of headframe no. 2.

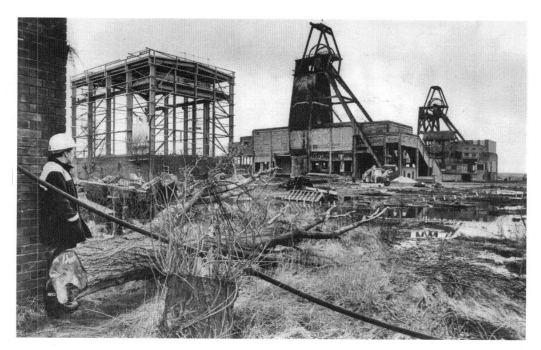

Disappointingly, on 12 January 1988 the *Don. Star* said British Coal had announced that poor industrial relations 'will halt the £111m re-opening of Thorne Colliery ... South Yorkshire Area Director Ted Horton said he was waiting for the NUM to agree to flexible working ... Mr Horton said: "I am prepared to keep the pit on ice for as long as it takes."' There was no movement on the problem three years later and the *Don. Star* of 9 January 1991 headed an article 'Another year and pit giant sleeps on', mentioning: 'Thorne is still on a care and maintenance basis.' Four years later, the *Don. Star* of 11 January 1995 said: 'Thorne Colliery has been bought by Haworth based RJB Mining as part of Richard Budge's new coal mining empire.'

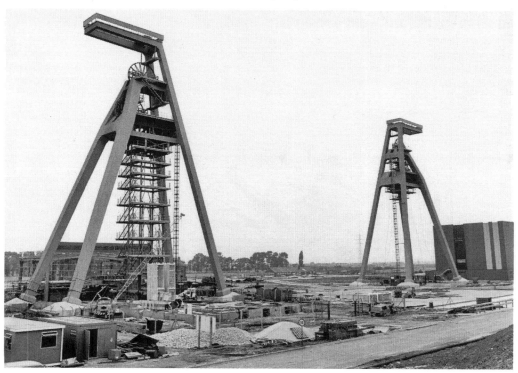

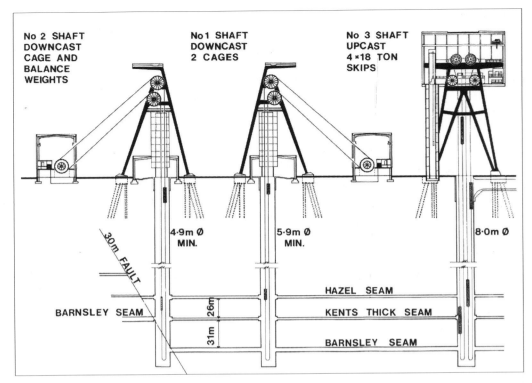

The diagram shows the comparison of winding arrangements in the shafts and illustrates the seams below the surface. The *Sheffield Telegraph* of 12 November 1982 provided details of the headgear: 'The NCB's space age steel towers, designed by Sheffield architects Husband & Co with the aid of a computer, have won one of three Constrado structural steel design awards, presented yesterday by Lord Caldercote ... From a distance – and the two towers can be seen for miles – the pair look like something from a US space centre ... The towers have met with a mixed reception locally. But in the words of one architect each tower is a "visually striking asymmetrical tetrapod in box-member steel work".'

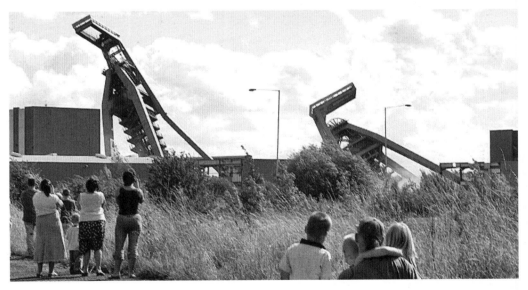

In 2002 it was decided uneconomical to persevere with the new colliery, even though there were still massive reserves of coal left in the High Hazel and Barnsley seams. Finally, the pumps were turned off in mid-2004 and on 18 August 2004, the new headgears were blown up.